MEDICINE SEEKER

A Beginner's Walk on the Pathway to
Native American Spirituality

Written and Illustrated by

Stan E. Hughes
HA-GUE-A-DEES-SAS

Bobcat

NorLightsPress.com
2721 Tulip Tree Rd.
Nashville, IN 47448

Printed in the United States of America

ISBN: 978-1-935254-23-2

Cover Design by NorLightsPress Graphics Department
Book Design by Nadene Carter

First printing, 2010

Coyote

Table of Contents

Antelope

Dedication

To my elder spiritual-cultural brother Bobby Lake Thom, Medicine Grizzly Bear, (Karuk - Seneca - Cherokee), who walked into the Spirit World to find my name, *Ha-Gue-A-Dees-Sas* (Man Seeking His People), and who patiently guided me as I learned to carry that name. His Creator-given gifts as a Native Healer allowed my son and youngest daughter to mature into healthy, productive people.

To my life-long pal Adam Hudson, *Ee-che-MAH-ne We-CHOSH-teh*, who embraced the magic of the Black Hills of South Dakota and taught me to listen to the timeless beating of her living heart.

Eternal thanks to the elders who saw me with kind eyes. Grandmother Grace Ware burned with the fire of spirituality and taught me to stand up for my beliefs. In a strange magical way, her love of music found its way into my heart. Doctor Waldemar Dahl, my Russian language professor lifted my arms to show me how to touch the sky. Uncle Dan Iyall helped me develop my Indianness with humor and intelligence and modeled the positive tenacity to bring about worthwhile change in the venue of Indian education. Chief Delvis Heath of the Warm Springs Tribe of Oregon blessed my ceremonial pipe and showed me the true meaning of leadership.

And especially to Phyllis Betts, the heart of my heart and the tender part of my life.

Preface
Why I Believe

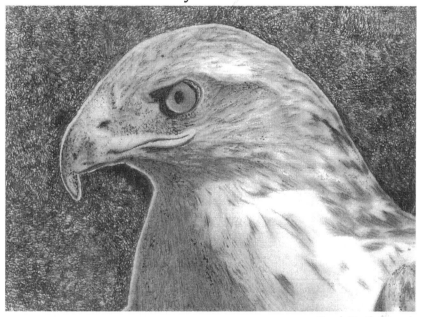

Red Tail Hawk

Severe depression gripped my beloved young son. Still a teenager, instead of brimming with life and energy, he'd become introspective and distant, spending hours sequestered in his bedroom. He avoided other people and began showing suicidal tendencies that frightened me. Our family doctor prescribed antidepressants and anti-anxiety medications. We visited a well know therapist who dealt with suicide and was willing to take our case. Even the minister of the nearby Christian church became involved in our plight and tried to help. But nothing changed.

Embarrassed, but hopeful, my son and I visited my friend and spiritual-advisor, Bobby Lake-Thom (Medicine Grizzly-Bear). In accordance with Indian custom and law, I offered Bobby a pouch of tobacco and a money gift, then told him about our problem and asked if he would be willing to doctor my son in the ancient Native

ways. After all, weren't Medicine Men and Women the first psycho-therapists?

As a purification procedure, Bobby smudged both of us with the most pleasant and aromatic cedar and sage smoke, then presented his Sacred Ceremonial Pipe and started a prayer invocation. His eyes were closed, but with his spirits, he conducted a scan of my child and me. I saw my son's eyes open wide in panic when Bobby growled deep in his throat, then sang one of his Bear songs. The Native Healer opened his eyes, looked directly into my son's eyes, and said, "I see you brought along your friend."

Puzzled, we both looked at the Medicine Man. All I could say was,"What do you mean?"

Bobby replied, "Teddy has the ghost of a teenage boy following him around and pestering him." He turned to my son and inquired, "Do you ever have any bad dreams about such a person?"

My son, a slim six-footer, broke down and began crying and shaking all over. He quietly responded, "Yes, and he always wants me to go with him back to a room I lived in when I was an exchange student in Norway. He keeps trying to get me to go to the cemetery in that city. Then I have dreams about killing myself. He wants me to do it and keeps encouraging me so we can be together."

My reaction was a combination of shock and pity. I had no doubt my son believed what he was telling me, yet I'd never heard of such a thing. I feared he'd end up in a mental institution. I knew children sometimes had invisible friends in their early years, but this was way beyond that idea. And whoever heard of an invisible friend trying to convince a child to kill himself?

The Medicine Man went back into his meditation and told us later he was talking to the ghost while his own Protector Spirits held it captive. He wanted to verify what my son said was true, and also find out why the ghost was tormenting him. Returning to the corporal world, Bobby asked, "Did you know a teenage boy your age committed suicide in that bedroom where you slept in Norway?"

My son quietly answered, "No." Then he added, "But I had several dreams about something like that over there, and again after I got back home."

Bobby told me this was why Teddy was depressed and wanted to end his life. I turned to my son and asked, "Why didn't you tell me, the therapist, or even the minister about this?"

"Because," he replied in sadness, "Who would believe me? And

what can anyone do about it anyway?

Grizzly Bear drew upon his many years of healing and doctoring others and began making arrangements for a special ritual to be held at a sacred place in Nature at the time when Grandmother Moon's walk across the night sky would be strongest. The location would be near a lake so a certain Water Spirit could assist, and also isolated enough from the busy hum of modern civilization, so his Bear Spirit would join us. (Little did I know an actual live bear would enter the ceremony.)

In the wild Selkirk Mountains where the borders of Washington State, Idaho, and British Columbia come together, is a sacred place called Sullivan Lake. This was selected as the site for the healing rite. One enchanted summer evening we gathered around the Sacred Fire. An ancient and time-honored ritual began. The Medicine Man offered tobacco and Grizzly Bear root (Angelica) and made an invocation that stirred our souls. He prayed in his Native tongue to the Great Creator, to the Earth Mother, to his Spirit Allies, and especially to Grandmother Moon, who was joyfully singing in the heavens directly over us, and to the Good Spirits that resided in the lake. He smudged Teddy and had him remove all clothing. Then he led him away from the campfire and made him wade into the icy mountain lake as he continued to pray and sing over him.

My son was terrified, embarrassed, and cold, he but found the resolve to continue the ceremony. I was observing the Native American equivalent of a full immersion baptism, but the Native Healer used the natural powers of Nature for the earthly element. My son was coaxed into jumping full-body into the freezing water in order to be purified, doctored, and protected. When he came up out of the water, he let out a whoop of joy that echoed off the mountains and warmed our hearts.

Then a strange and frightening event occurred. An adolescent bear crashed out of the tree line, bounded across the sandy beach, and headed straight for my son. Bobby stepped between them and began speaking to the bear in his Native language. The bear stopped and seemed to listen as the Medicine Man sang an ancient Bear song. In the moonlight, it seemed they were dancing together.

The rest of us ran for the protection of my Chevy Suburban. After a few moments, Bobby came over to the car and asked me to give him the food we'd brought to put in the fire for payment to the Bear Spirits. He walked back to the young bear, placed the food on

the ground near the creature, and stepped back. The bear growled, picked up the food in his mouth, and disappeared into the night.

Later, my son rested under a blanket by the fire and said he felt different. Even in the moonlight, I could tell he sat taller and his eyes were alive.

As the days, months, and years passed, he was never again tormented by ghosts or overwhelmed by mind-numbing feelings of depression. He moved on with his life in anticipation and joy, earned a master's degree, and is becoming an expert in the field of art history.

We will never forget that special night and the sacred ceremony performed by Medicine Grizzly Bear.

That is why I believe.

I ask you to join me on the pathway to Native American spirituality. You will hear the voices of Medicine People and Native Healers as they patiently guide children of the Modern Age into a wondrous world, ancient and sacred, yet relevant today. You will experience their knowledge and their medicine. As you travel through the pages of this book, I hope you will find meaning for your personal journey.

◊◊◊◊

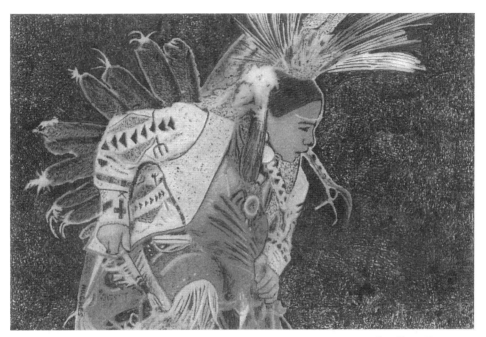

Indian Dancer

Creator God and Mother-Earth
Wak-kon'-ton-kah and E-nah' Man-koh'-cha

Great Spirit stood on the Mount and looked at all He made.
North-South-East-and West, He liked what He surveyed.

Mother-Earth sat by His side, and tears were in Her eyes.
Creator-God looked with concern, "Tell me why you cry."

"I'm lonely."
"How could this be? I am always with you."
"You made me to be a Mother, but I have no children."

Great Spirit took some clay and formed a Mortal Man.
With infinite variety, He continued with His plan.

Two-leggeds, Four-leggeds, Flyers and those who swim,
All felt the warming sun and a sacred breath from Him.

Mother-Earth spread her arms and pulled them to Her breast.
"I love you all, my children, from the great to very least."

Ha-Gue-A-Dees-Sas
2007

Chapter 1
In Communion With the Great Spirit

We Dance for the Great Spirit
Song of the Spirit-Dance
Thus the Father saith,
Lo, he now commandeth all on Earth to sing,
To sing now.
Thus he hath spoken,
Thus he hath spoken,
Tell afar his message,
Tell afar his message.

(Curtis 1987)

The mood was hypnotic. Ten young Inupiat girls dressed in traditional gray seal-skin tunics and breeches with white fox fur coverlets at their wrists stood in a half-circle, facing an appreciative audience. Soft, blue lighting on the stage in the exhibition hall in Anchorage, Alaska gave a sense of a great ocean silently awaiting a primordial baptism.

The hand drum began a heartbeat rhythm: quiet, steady, and reverent. In perfect unison the girls began swaying their bodies, feet never moving. They were the magnificent sea mammals of the cold Arctic waters: The walrus ... the seal ... the narwhale ... the great blue whale ... mirroring the motions and spirits of each magnificent sea creature.

Then they were the polar bear, sniffing the air, peering left and right, standing in great confidence, the queen of all she surveys ... yet their feet were motionless on the stage floor. Almost imperceptibly, the drumbeat quickened and their white fur coverlets became all the Flyers of the air flitting back and forth, up and down, as if in some marvelous courting ritual. I could no longer see the young girls, only the ghosts of white motion, alive and unfettered. I couldn't breathe ... it was magical.

The drumming ceased ... echoes in my mind of the sea washing the bleak rocky shores of the Far North blended into the sound of audience applause. Reluctantly, I came back to reality. These young Eskimo girls had whisked me away from a steel and plastic environment to a place ancient and clean. I felt refreshed, yet strangely chilled.

◆◆◆◆

An entire book could hardly begin to describe the amazing dances of American Indians and Alaskan Natives. The First Nations had dances to thank the Great Spirit: marriage and birthday dances, dances to help with the harvest, fishing and hunting dances, dances performed for fun and enjoyment, and dances for religious ceremonies.

Unlike European dancing, Indian dances celebrate a physical connection to Earth Mother and all Creation. This expression is so versatile it can reflect joy, community, and celebration on one hand; sorrow, fear, subjugation, pain, and even war on the other hand.

Native dance sends a direct message through the feet, vibrating the ground to tell the Mother of All-Mothers: "I am alive one more day! Feel me touching you with my body! Feel my heart beat through my heels and toes! I am alive! For one more day."

I have attended powwows and dances from coast to coast, from Alaska to Mexico. Each form of dance is as varied and individual as the Nations, tribes, and villages performing them.

So many dances. So many songs. So many stories.

◆◆◆◆

The Sun Dance was, and is, the most spectacular and important religious ceremony of the tribes that roamed the Great Plains of North America. Each tribe held the dance once a year at the time of the Summer Solstice when the sun is most dominant in the heavens. The sun dance lasts from four to eight days, depending on the stamina of the participants and the practices of each tribe. Traditional believers feel it represents the continuity between life and death—a regeneration—and illustrates that life is a circle of symbolic death and rebirth.

Preparation for the dance is time-honored and specific. Chosen tribal leaders search for a cottonwood tree with a fork in the top. The tree is cut down and a sacred offering made to its spirit. Maidens in their best regalia strip the tree of its branches, and in some cases even

the bark. The next morning, warriors ceremonially attack the tree in a symbolic effort to kill it. Before the tree is erected as the sun-pole, offerings may be attached to the fork, such as medicine bags or a buffalo skull, or in the early days an actual buffalo head. Similar in a way to the European May pole, leather thongs so long they droop to the ground are tied to the top of the pole. The pole is erected and set firmly to represent the center of the world, connecting the heavens to the earth.

The dancers have the upper part of their chests slit, with two side-by-side cuts near each shoulder. Some groups slit the dancers' backs in a similar fashion. A wooden peg, or sometimes an eagle claw, is painfully inserted, then one end of the long leather thong already attached to the sun-pole is tied to the peg. The dancers cannot eat or drink and must step to the sun-pole to the beat of the drummers, or the plaintive tooting of deer whistles, then dance backward, pulling the thong tight to inflict thought-numbing pain on themselves. Over and over they do this, until the skin tears and they tumble to the ground in exhaustion. Sometimes a dancer collapses in the oppressive heat before his skin tears.

Tradition says the sun dancer is reborn mentally and spiritually, as well as physically, and his efforts guarantee continuation of the buffalo—and the entire universe. Through ignorance and fear, the United States government outlawed the sun dance in 1904, stating it was cruel and barbaric. Today, this sacred ritual has again found its place in the ceremonies of the Traditional Native religion.

◊◊◊◊

The Hoop Dance takes incredible training and skill and is exciting to watch. Traditionally the dancers are male, but in recent years women have begun participating. Dressed in the full regalia of his Nation or tribe, the dancer uses up to thirty-six hoops decorated with Native American runes. Each hoop is two or three feet in diameter.

The purpose of the hoop dance is to fashion shapes and designs without dropping even one hoop, meanwhile keeping time with the drumbeat. The performer steps into hoops in a symbolic gesture of being included in the Circle of Life.

The hoops are formed into the shapes of snakes, butterflies, flowers, coyotes, and eagles, and it's amazing how an armload of hoops can be made to represent these creatures. Toward the end of the dance, the dancer forms his hoops into circular three-dimensional balls that represent the world or the sun.

◆◆◆◆

The Grass Dance is a vigorous dance performed by men and boys dressed in outfits made of cloth and long, colorful strands of ribbon, fabric, or yarn reaching from shoulders to feet and representing grass. Cloth or yarn fringe decorates the feet. Dancers often carry a decorated stick or a medicine wheel. As the dancers move, the strands on their bodies flow and undulate like grass blowing in the wind.

Several stories are told about this dance's origins. Most practitioners agree the original purpose was to beat down high grasses of the plains to prepare an area for teepee sites and ceremonies—and scare away snakes. The dancers stamp their feet to the beat of the drum and move in what appears to be a random, somewhat circular pattern reflecting the motions of warriors stalking game or their enemies. A skilled dancer seems lighter than air, moving like the wind.

The grass dance is said to reflect the need for balance in life. Although it began as a Plains Indian ceremony, this dance has been adopted by other tribes and is performed in powwows and dance competitions from coast to coast.

◆◆◆◆

The Cherokee Stomp Dance, the most sacred and complex dance of the Cherokee people, is performed with unique protocols and differences for each dancing ground.

The Fire Keeper and his assistant build a sacred fire at dawn on dance day and keep it burning throughout the day. Seven arbors are built on the grounds around the fire as a dancing area for the seven clans. The dance cannot begin unless each clan is represented. Women prepare a sumptuous meal for the day, consisting of traditional and modern food such as corn, beans, chicken, and normal picnic fare. At sundown the ceremony continues, with the chief of the hosting clan presenting the traditional smoking pipe and handing it to the Medicine Men of the six other clans.

The chief, medicine men, and elders hold a meeting, then issue the call for the first dance, and then the second call. The first dance is by invitation. The dancers are tribal elders, visiting non-tribal elders, medicine men, and clan heads.

Dancing continues until the next sunrise. Participants include a leader, assistants, and one or more female shell shakers who wear leg rattles traditionally made from turtle shells filled with pebbles.

The dance cannot begin without the shakers, who provide rhythmic accompaniment while dancing around the fire.

Because the stomp dance is a sacred ritual, ancient Cherokee wampum belts are shown at this time.

The Kiowa Gourd Dance is a ceremony to honor warriors and elders of the tribe. A group of elders are seated around a drum placed in the center of the dance area. The drummers begin a quiet, rhythmic beat, and warriors gradually appear around the edges of the dance area, each wearing part of a military uniform. The oldest warriors may be clothed in World War II uniforms or Korean War field jackets. Vietnam Veterans and Desert Storm or Iraq War soldiers in traditional regalia with feathers or animal skins may also wear medals and shoulder patches to signify their sacrifice.

Every dancer wears a red and blue scarf draped over his shoulders and carries a gourd rattle. To the Kiowa, red stands for their ancient battles against the Spaniards, while blue represents fighting the United States' cavalry in the 1800s. As the dance continues, the warriors slowly move inward toward the drum, while other tribal members join the periphery. Eventually, women and children with shawls and blankets thrown over their shoulders, join at the fringes of the dance area, and spectators are invited to participate.

Kachina Dances are performed in the Hopi villages of the American southwest. The men of the Kachina society, colorfully masked and costumed, emerge from kivas and pour into the village square to chant and participate in line dances and other rites that can last for days. Members of the village prepare feasts and share bounty with one another, while trading Kachina dolls that represent the cloud people and other significant spirits.

As each dancer performs, he receives the spirit of the kachina he represents, and so acquires power to send prayers to the deities. In addition, clown figures called koshares add chaos to the occasion and serve to illustrate mankind's moral failings. On the ceremony's final evening, the chief female spirit of the Bean Dance ceremony leads the other kachina representatives into the sunset, where they return to the mountains until called again.

Pacific Northwest Story Dances are performed by many tribes

of Alaska, Washington State, Oregon, and Canadian First Nations residing on the Pacific coast and Puget Sound. In modern times, a narrator tells the story, and dancers perform that tale or myth through the use of elaborate masks, eagle and raven feathers, cedar bark aprons, beautiful blankets and shawls, ceremonial props, and hypnotic drum and wooden whistle music. Some of the masks are actually masks within masks and can be up to five feet long, or larger. As the story unfolds the outer mask opens, revealing a chilling sight inside.

This marvelous style of storytelling and dancing was used to help pass the dark, dreary winter days of that region. The masks were carved from pliable cedar wood and painted in black, red, white, and blue, using images and designs established long ago. Each story followed oral traditions handed down for generations. The tales usually explain some natural phenomena, tell about the tribe's origins, or honor spirits of the creatures that provided survival and sustenance for the tribe, along with a prayer that the relationship will continue.

Powwow Dances received their name during American colonial times. As the story goes, a group of Europeans who watched Algonquian medicine men dancing heard one of the dancers called Pauwau and mistook his name for the title of the ceremony. Over time, the word powwow was used for all tribal gatherings.

Across North America, the First Nations People have always found time to celebrate their culture and socialize with family, friends, and neighbors. For a short time, they set aside the mundane trials of life and enjoy a wonderful party, where dancers in their finest traditional outfits and most precious regalia provide a kaleidoscope of color and motion that lifts the heart and re-charges the spirit.

For the First People of every tribe and community, powwow dances share a common thread. After a glorious grand entry, the dancing begins—sometimes as a competition, and at other times to celebrate life, offer homage to the Creator God and his creation, or just to have fun.

Spectators might see an Intertribal Dance where everyone is welcome to participate—even tourists. Other events include Men and Women's Traditional Dances, Fancy Dances and Shawl Dances, Jingle Dress Dances, The Oklahoma Two Step, a Circle Dance or Friendship Dance, Team Dances, and dances to honor animals like

rabbits, prairie chickens, snakes, or eagles.

◊◊◊◊

The *Owl Dance* is especially interesting. During this social dance, each woman selects a man to dance with her. If the man refuses, he may forfeit a piece of his regalia or have to pay the woman money. This is a couple's dance in serpentine fashion, using the Oklahoma two-step and always preceding in a forward motion. In this way, the woman can show off the man of her choosing.

◊◊◊◊

White men who ran roughshod over Native American culture assumed Indian dances always led to trouble and took extreme measures to bring this magnificent art form to extinction. For many years, public laws and restrictions forced Indians to dance underground, away from the eyes and ears of their suppressors.

Go to any Native American celebration or ceremony today and you'll see the efforts to abolish native dancing had little effect on how the Indigenous People express themselves. Dancing is an inspiring art form that touches everyone in a gentle, often personal, way.

Power Centers and High Places

From the very beginning of creation there have been "power centers."

Our elders taught us that the Great Creator made such places for a reason and purpose. Ancient myths and stories teach us that power centers are sacred places where the spirits or protectors reside. Some religious doctrines reveal that specific power centers are where one goes to make a direct contact with the Great Life Force which flows through all living beings: Seen and unseen. Such places are sacred and holy, hence they should be respected, protected, preserved, and used appropriately.

Medicine Grizzly Bear Lake
1989

Power Centers on the North American continent were revealed to the Indigenous People in ancient times, and although many of them are now lost—or located in the middle of a football field, a housing project, or state or national parks—other locations have passed through generations and are still used by Traditional people. These holy places are often found near important features, including the Four Corners area of the Navaho Reservation in Arizona; Mount

Shasta in northern California; The Olympic Mountain Range; Mount Rainier, and what's left of Mount St. Helens in Washington State; the Medicine Wheel in the Big Horn Mountains, and Devils Tower in the eastern part of the state of Wyoming; Bear Butte near the Black Hills of South Dakota; Niagara Falls, and the Herkimer area in New York; Mount Washington in New Hampshire; The great Smokey Mountains of Virginia and Tennessee; and the burial mounds in southern Illinois. Within these areas the Native people sought out caves, waterfalls, prairie mounds, isolated ocean beaches, secluded forests and meadows, plateaus, prominent rock formations, high mountain lakes, and special river bank areas to perform their rites and rituals.

Native people who still honor the old ways know high places are inhabited by spirits or protectors who are part of a sacred power hierarchy. They believe certain power centers mark where the Great Spirit came to earth in ancient times and stopped to survey his dominion. Other locations belong to special spirit beings of high status, or a particular family of spirits. The grandfathers of the Four Sacred Directions use the most powerful of these centers as resting places when they're walking the Earth. Even a simple waterfall or small cave in the side of a rock face may have a spirit in residence. Though less powerful than the grandfathers, these spirits deserve acknowledgement and honor from the Two-leggeds. Indian elders teach that when a power center is violated, the first reaction is a warning. A serious penalty follows if repentance and reparation are not performed.

Humans who worship at a power center usually hope to receive something they need or want. The request might be complicated, such as the power to heal others physically, mentally, and spiritually. Or it could be a personal wish, such as gambling luck or strength and stamina for an upcoming athletic event. Special protocols and respect must be observed, starting with purification of the body, mind, and spirit. In many cases this is a four-day ritual that includes cleansing in a sweat lodge or sweat house, fasting, and prayer. During this preparation, the participant invokes the Great Spirit and the spirit of the power center and asks for permission to walk and pray on that sacred ground. The visitor must abstain from sex, drugs, alcohol, and any possible contamination from human or animal blood. A sign or omen must be received that tells the initiate he or she may proceed. If no omen occurs, the trip must be cancelled or postponed

until a later date. No questions asked.

In certain power centers, one makes a pilgrimage not just to take, but to return blessings previously given. This implies a reciprocal relationship and responsibility between the Two-leggeds and the Earth Mother. Humans can give the Earth positive, loving, creative energy. The Earth Mother opens her heart to these efforts. Traditional medicine people believe their offerings, cleansing, fasting, and sacrifice help keep creation alive.

Every power center or high place should be respected and protected. As churches and temples of Traditional Indigenous People, they are special and sacred. Protecting the sanctity of such places has led to many conflicts with government policies and real estate developers. We would do well to communicate with the original inhabitants of an area and gain permission before we move in, vacation, or blissfully blunder onto holy ground. Our ignorance is no excuse for violating holy places.

Four
Doh'-pah

The Circle of Life gives it sweet breath,
I'm born, then childhood, old age … and death.
Four Elements are with us since birth:
Our sisters: Water … Wind … Fire … Earth.

Summer or Winter … Autumn and Spring.
The Four Seasons weld their sacred ring.
On Two Legs or Four Legs, Fins or Wings,
All are the children Earth Mother brings.

Yellow and Scarlet … Black and Snow White.
Sacred Colors bring us their kind light.
The Directions … South, North, West and East.
Not one the most nor one the least.

Our Father … His Son … and Holy Ghost;
Tell me which one we should love the most.
We know the Sacred Number is Four;
So their Triune God still needs one more:

Our Catholic Fathers praise another:
She is Mary … the Holy Mother.

Ha-Gue-A-Dees-Sas
2007

Chapter 2
The Sacred Circle

Medicine Wheels and Sacred Hoops

The circle, known as a medicine wheel or sacred hoop, is a sacred symbol for nearly all traditional American Indian and Alaskan Native cultures.

Even today, traditional Native people carry these symbols with them and include them as part of their regalia—the ceremonial or dancing clothing and accessories used in rites and rituals. These wheels once served as an encyclopedia, almanac, atlas, and bible. They were most often constructed from materials of the Earth: bone and sinew, willow boughs, quills, grasses

Osprey

and reeds, and were sometimes painted in red, white, yellow, and black, and decorated with colorful thread, string, ribbon, feathers, beads, bits of fur, or plant life.

Early American Indian and Alaskan Native cultures were cooperative societies that depended upon the link between the Great Spirit, man, animal, and plants to continue hearing the heartbeat of the Earth Mother. Each group's religious beliefs passed by word of mouth from generation to generation, through the centuries.

The medicine wheel is circular, with two connecting diameters meeting in the middle at a 90-degree angle from one another. This divides the artifact into four equal pie-shaped sections. The hoop may be as small as a quarter dollar, or spread on the ground, hundreds of feet across and constructed of stones and rock cairns. Traditional Sioux villages replicated this sense of roundness with round fire pits, teepees, families clustering inside their wigwams forming a ring with each other, and entire villages laid out in a round

shape for protection as well as to replicate the Sacred shape. Holy men expanded on this sense of circle by explaining the entire Sioux Nation was made of a large hoop of Seven Campfires. The universe was itself circular and consisted of the earth, which is round, the sun, which appears round, the stars, the moon, and rainbows—circles within circles within circles.

The traditional Native person believes in the sacredness of a life circle where everything has its own place, from the tiny ant perched on a leaf to Father Sun. He considers another Two-legged, Four-legged, Flyer, or Swimmer a brother or sister, understanding all living beings are children of the same Earth Mother in a family circle of infinite variety.

The Four-ness of the Sacred Circle

In olden days, the time for spiritual learning arrived when a child was old enough to understand the world was greater than the things he could hear, see, feel, smell, or taste. The teacher might be an Elder, the village holy man, or a venerated family member, such as a respected grandfather, father, or uncle. Teacher and pupil each held a medicine wheel, and as the lessons began they turned the hoop in their hands. The words flowed:

"There are four People of the Earth: The Two-leggeds, like us; the Four-leggeds, like the buffalo or elk; the Flyers, like the eagle or the hawk; and the Swimmers like our fish brothers and our frog cousins. And there are four races of Two-leggeds: The Red, the Yellow, the Black and the White. All of these People are to be respected and are all children of the same Earth Mother.

"The four Sacred Directions are represented by four Sacred Colors. Red is for the East and reminds us of the rising sun; Yellow is for the South where the yellow flowers bloom; Black is for the West where the darkness starts when the sun sets and where the Crow tribe comes to make war with us; and White is for the North from where the snows blow in.

"The Circle of Life has four times: Birth, Adolescence, Adulthood, and then Death. All four are of equal worth and importance, and everyone who lives a full life will pass through each of those stages. You know you've reached Adulthood when you get your second name.

"We have four sacred parents and grandparents in our lives: Mother Earth, Father Sky, Grandfather Sun and Grandmother Moon.

"Each year, four seasons walk the Earth Mother: Spring, Summer, Autumn, and Winter.

"Four earthly elements grace our lives and provide for our survival and sustenance: Wind, Fire, Water, and Earth."

"Each of us is made up of four people: our Bodies, our Feelings, our Minds, and our Spirits."

With the medicine wheel or sacred hoop as a visual symbol of balance and completeness, American Indian and Alaskan Native elders taught their children how the entire universe is divided into four equal parts of the Great Circle.

Our universe is circular. This knowledge brings enduring hope that things will always work out, no matter how dire they seem. After every winter, spring will come.

Breaking the Sacred Circle

The general beliefs of the Indigenous Peoples of the Western Hemisphere involve seeking harmony with Self, Others, Nature and the Great Spirit. They viewed other creatures, animal, plant, and rock as family and treated them with respect, always striving to walk softly on the Earth Mother.

The Sacred Circle had occasional breaks, creating the need for war and warriors. Even so, inter-tribal conflicts were usually brief, with no need for standing armies. Native groups fought over hunting, fishing, and gathering grounds. They stole each other's women and horses, and some tribes were always on the lookout for slaves. The Skagit Indians of the Pacific Northwest and the Susquehannock of the northern Chesapeake Bay area were especially aggressive and often wreaked havoc on their neighbors. Despite the occasional aggressive relationship between tribes, all held special respect for sacred ground and would not wage war at those places. An example of this was The Valley of Flowers where the city of Bozeman, Montana now stands. In the spring and summer a lush carpet of flowers and plants covered this vast, high valley, and the tribes considered it neutral territory — a sacred hunting ground. If a group of hostiles was pursuing another group, reaching this remarkable valley brought an end to the chase. Then came a stand-off period as each tribe waited to see who would leave first.

The Native People could not live in harmony with White Man

who encroached on the Sacred Lands of the Western Hemisphere. The terrible battles led to senseless savagery on both sides.

On a more personal scale, there were, and still are, small wars between families and family members. Villages had bullies and children who were unkind to the small, the disabled, and the different. In some tribes, fathers bent an unyielding ash wood bow across the children's backs for misbehavior. In other American Indian and Alaskan Native cultures, parents didn't discipline the children because they believed alienated children wouldn't care for them in their old age. Discipline was performed by a grandfather or uncle. Some American Indian tribes in the Northwest and Southwest had a whip man or woman who rode into the village on a regular basis to administer corporal punishment to the youngsters. This person was held in great esteem by the village and deeply feared by children. Adding insult to injury, the children had to cut the willow branches used to warm their own backsides.

In today's broken world, Native American women are sexually assaulted more than twice as often as non-Indian women, according to a report by Amnesty International. Domestic violence has become so common on many Indian reservations that fewer cases are reported or actually investigated, and fewer still brought to some form of resolution. The on-going and reprehensible issues of alcohol and drug abuse have decayed the spirit of Native people for hundreds of years. Hence, another set of variables break the Sacred Circle.

Based on the Sacred Circle, each traditional group tried to strike a harmonious balance with nature instead of trying to control the environment. Though agrarian tribes were charged by the Great Spirit to dress, till, and keep the earth, poor stewardship happened across the entire continent. Some groups planted crops over and over without thought of conservation or replenishing the soil. They were forced to relocate when the tired earth could no longer produce. Some ethnologists believe this was why cliff dwellers of the American Southwest abandoned their homes and disappeared into history.

During the 1800s, the philosophy of Manifest Destiny sent the White Man deeper into Indian Country, convinced he had a divine right to everything in his path. The great Native philosopher and seer Black Elk spoke for those who had no voice. Black Elk clearly saw how the westward migration of Europeans would disturb the life balance of the sacred circle and lead to the death of native culture.

Soon, American Indians were restricted to reservations, unable to carry on traditions handed-down for countless generations. The unwelcome visitors brought disease, alcohol, poverty, dependency, despondency, and hopelessness.

Almost any United States map contains small, irregular shapes sprinkled from coast to coast and border to border, usually in gold, brown or pink, and labeled "Indian Reservation." Every state in the union has at least one reservation.

Different tribes or bands were crowded into a single reservation, though these groups had little in common and some were traditional enemies. White men clung to the misguided view that all Indigenous Peoples were the same.

A sad example of this misguided view involved The Last Wild Indian. In 1911, Ishi, the last living Yahi Yana Indian was found in the western Sierra Nevada foothills, crouched against the fence of a corral in a slaughterhouse. He was starving and totally naked except for a piece of canvas he'd fashioned into a poncho. Two University of California anthropologists got involved and helped him achieve a semblance of health and security. The United States government offered to provide transportation and expenses to any Indian Reservation in the country where Ishi wanted to live. This was like offering a Greek the chance to live in any town in Iceland. Ishi stayed at the University of California and worked as a janitor in the Museum of Anthropology until his death from tuberculosis in 1916.

Federal reservation boundaries ignored culture, economics, and territorial rights. By contrast, the traditional boundaries of Indian tribes, though occasionally points of contention, were well identified, time honored, and extended huge distances.

Most reservations were set up on abandoned military property or other land no one else wanted. The United States government gave no thought for the gathering of fruit and berries; the hunting grounds of buffalo, deer, elk, and other large animals; or traditional fishing grounds and water passages for collecting sea life. Nor did the reservations allow for the trading that was a vital part of inter-tribal cooperation and economics. The ignorance and imperious behavior of the United States government remains a pathetic monument to how the sacred circle was broken—and remains broken to this day.

◊ ◊ ◊

Father Sun and Summer Rain
Ah-teh' We and B'doh-keh'-doo Mah-gah-zh

Brittle dry, Earth raises her sad eyes,
Wearily scanning the empty skies.
Father Sun mercilessly has his say.
When will She see relief on the way?

And then Brother Wind sings His sweet song,
"Be patient, My Dear, it won't be so long.
I've called to the Clouds, they're coming back.
Look to the Sky. They know what we lack."

At first, that fragrance so moist and pure.
The first welcome sign that rain drops near.
And then a cool hand sweeps 'cross the plain.
Father Sun smiles and plans his refrain.

Gentle rains fall … an off'ring of love.
Earth's laughter rings to the skies above.
Father Sun looks down with a wry grin,
"I will return to test you again."

Ha-Gue-A-Dees-Sas
2007

Chapter 3
Sacred Rites and Rituals

The Smudging Ceremony

Traditional Native doctor Tila Starhawk Donohue spread a worn cloth on the floor beside her. The plaintive flute music of Carlos Nakai wove a tapestry of gossamer threads, holding the past and the present in suspension.

In the dim candlelight, this small American Indian woman appeared timeless and holy as she prepared the altar for my first smudging ceremony. We sat cross-legged on the floor, in a circle. Looking around the group, I realized most of us felt unsure and a bit nervous about what would soon happen.

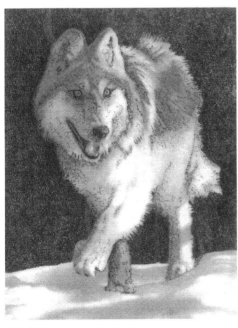

Wolf

Smudging is a common purification and bonding ritual among Native groups across the Western Hemisphere. Since my initiation to this practice, I've witnessed smudging in Alaska, the Pacific Northwest, the Midwest, and the Southeast. Though different materials are burned, the ceremonies are similar.

The Medicine Person or Shaman places sweet grass, sage brush, juniper or cedar, herbs, and tobaccos onto a flat stone, in a wooden bowl, or within a dried and polished abalone' shell.

❖❖❖❖

Tila turned off the flute music and reached behind her. Silently and reverently, she lifted an item from a paper grocery bag. It was a stone mortar bowl—solid granite, heavy, and cumbersome. The top of the bowl had been worn away by mortar and pestle work until it was smooth and deeply concave.

In my mind's eye, I saw an endless ribbon of Indian women furling into the past; each working diligently with the bowl to prepare sustenance for her family; each making the depression a little deeper as she ground herbs or grain for cooking and rituals. This implement reminded all of us how ancient smudging rites are. A sense of continuity with the old ways embraced us. We were part of an endless continuum.

Tila placed a large abalone shell, blackened with soot from many uses, within the stone mortar's bowl-shape depression. Bits of mother-of-pearl still glistened where blackness had not yet covered the shell. Her young-girl's voice chanted the welcoming song:
Hey hey hey-heya un-guh-lah
Hey hey hey-heya un-guh-lah ...

We watched, riveted, as she filled the shell with pieces of dried cedar bough, sage brush, and assorted small leaves and herbs. The chant was hypnotic in its rhythm and repetitiveness.

After igniting the mixture, the Shaman or Medicine Person walks from one ceremony participant to the next, sweeping pungent smoke toward them with a feather fan or small tree branch. Sometimes, participants approach the ceremony leader to receive the smudging. The recipient inhales the aromatic steam, then cups the smoke in his hands and carry it to his heart, head and stomach—then to other parts of the body that might be debilitated or in pain. The ritual leader continues chanting, praying, or singing during this time.

When Tila lit the mixture, the blended vegetation flared into a red-orange flame, then died down, and a cloud of wonderfully fragrant smoke rose into the air. She lifted the abalone shell out of the stone bowl, held her beaded eagle feather fan with her free hand, and rose to her feet. She moved from person to person, enveloping each with

the sacred element as we stood to receive it. Some knew how to accept the smoke, others stood in silence with eyes closed. Again her voice sang across the darkened room:

Wen-day yah-ho
Wen-day yah-ho
Wen-day yah, wen-day yah,
Hey hey hey-yah-ho hey-yah-ho
Yah yah yah ...

In the fullness of time, each person was smudged and returned to the circle. Finally, Tila handed me the smoking ember, and asked me to smudge her. As if to recognize this special honor, my flying song rose from my heart and out my lips:

Yah Kee Oh-oh-oh
Moh-zhah Nah-lay ... Ay.
Peh-zheh Yah-kees-kay
Shah-nah neek Nah-zhee ... Ay.
Moh-zhah Nah-lay

Tila's eyes were open, but non-seeing. She embraced the smoke in a slow, deliberate motion as if someone else moved her arms. In a few moments she came back to us, returned to her place on the carpet, and seemed to drift away in silent meditation. We all sat in respectful silence until she communicated to us without speaking that the smudging ceremony had ended.

I had so many questions.

Later, I was able to visit with the Medicine Woman and ask, "What is this all about?"

I learned the moving smoke indicates our prayers are rising to Creator God, giving a visual sign something is happening. The smoke itself is a purification element, similar to the water used in Christian baptisms, or incense in the Catholic faith. Smoke permeates the hair and clothing, staying with participants after the ceremony as a reminder of Creator God's presence. Human beings are offensive to the grandfathers and the spirits because we smell bad to them. All the chemicals and impurities we inhale and ingest every day defile our hair and leak from our pores, noses, mouths, and other orifices. The smoke's sweet fragrance masks our foul aromas and makes us presentable and acceptable. The ceremony also provides health benefits for us. Physically, the healing smoke can clear up asthma,

bronchitis, and the common cold. Spiritually, the smoke can purify, neutralize negative energy, and dispel bad spirits.

The smudging ceremony was made illegal by the United States government, in yet another effort to destroy the religion of the American Indian, despite the fact that the Bible describes a similar ceremony in Leviticus:

> *And when any will offer a meat offering unto the Lord, his offering shall be of fine flour; and he shall pour oil upon it, and put frankincense thereon: And he shall bring it to Aaron's sons the priests; and he shall take thereout his handful of the flour thereof, and of The oil thereof, with all the frankincense thereof; and the priest shall burn the memorial of it upon the altar, to be an offering made by fire, of a sweet savor unto the Lord.*
>
> *Leviticus 2:1-2*

The ritual lived on through the generations in secret until it could be openly practiced and shared again. In 1978 the Federal government's Legislative Branch passed Public Law 95-341, called The American Indian Religious Freedom Act. This important piece of legislation made the following promises:

American Indians have the right to practice and participate in traditional religious ceremonies and rituals with the same protection offered all religions under the United States Constitution. They have access to and protection of sacred sites and public lands for ceremonial purposes. They may use traditional religious symbols and artifacts in the ceremonies and rituals.

This section of the law allows American Indians and Alaskan Natives to possess body parts from protected species, including eagle feathers, grizzly bear claws, and so forth.

The Magic of the Sweat Lodge

Medicine Grizzly Bear Lake asks the spirits to allow us into the Sweat Lodge:

"All my relations, please welcome me into the Circle of Life"

While we stand totally nude outside around the blazing campfire watching the lava rocks heat until they glowed, we forget the night is inhospitable—thirteen degrees, with a foot of snow on the ground. A mean wind swirls ice-like snowflakes into our eyes.

At last we are ready to enter the turtle sweat lodge, an igloo-like structure not five-feet high and less than ten-feet in diameter. Each participant utters words of passage as he crawls into the lodge's dark interior.

This is my fifth sweat lodge experience. The earlier ones were hot and oppressive; frightening because of the trapped feeling. The interior of the turtle lodge is confining and eight of us sit knee-to-knee around the fire pit. The singing, praying, and male comradeship; the sense of continuity with the ancient past; all these blend together for an incredible experience. But I couldn't forget the pain and feelings of claustrophobia. Why had I agreed to do this again?

The canvas walls of the lodge are stiff and frozen; the ground inside under the floor of fir tree boughs feels like cold concrete. No matter: soon it will be plenty hot. The Keeper of the Fire digs the first rock, larger than a soccer ball, from the pit and passes it inside through the open tent flap. The shovel wobbles with the glowing, white hot-stone. The medicine man hooks it with a deer antler and drags it to the hole dug in the middle of the lodge floor. Fir boughs crackle, smoke, and emit a pleasant fragrance as the rock touches them. The stone begins to turn orange as the cold earth sucks out the heat. Another rock ... then another rock ... then another. They fill the pit and begin to stack above ground level, inches from our bare knees. Already it is stifling hot inside the lodge and my knees sting from the heat pouring off the stones. I can see the others in the somber light: White and brown skins all looking the same; eyes reflecting the glow; mysterious shadows against the lodge walls outlining our heads and shoulders.

The perspiration flows—along with an immediate sense of cleansing.

First the timeless sweat lodge prayer:

> *Great Creator, we come before you in a humble manner and ask for your help. We offer these herbs and pray. To the four sacred directions and to the powers of the universe we pray. To the spirits of the air in the north, to the spirits of the fire in the east, to the spirits of the earth to the south, and to the spirits of the water in the west.*
>
> *We pray and give thanks to you, oh, Great Spirit. We pray*

and give thanks to the Grandfather Sun, the Grandmother Moon, to the Mother Earth, and all our relations ... because without you we would not be able to live and survive. We ask that you forgive us if we have ever harmed or hurt you. We pray, offer this tobacco and herbs and ask that you doctor us, heal us, purify us, and protect us. We pray for our elders, our women and children, and fellow human beings. We ask for peace, harmony, and healing worldwide.

And then again—the familiar and ancient prayers and songs in the Yurok Indian tongue of northern California. The chanting is hypnotic and seems like a heart beating. On silent feet, the here-and-now melts away, replaced by a world old, and clean. The spirit of the Earth Mother throbs in pride as she holds her children to her breast. For a brief moment, even the orphans the people call White Men, a race of Two-leggeds displaced from their roots by time and space, are embraced by the Mother of All Mothers.

And then the searing steam...

Our Spiritual Leader ladles the herb and water mixture onto the rocks. It hisses angrily and envelopes everyone in an oppressive blanket of steam. The uninitiated gasp and choke. Two primordial elements— fire and water—compete for dominance, as it was in the beginning.

More singing and chanting. We all join in, trying to ignore our discomfort. The voices blend in a rich, masculine aria.

More steam. Breathing becomes difficult. Fear and panic rise together as the human survival instinct cries, "Get out!" I must relax, control those feelings, contain those thoughts; this is not life threatening. I begin feeling better.

Something is frighteningly different this time. The Medicine Man doesn't continue the usual rituals. No praying, no more water striking the blistering hot rocks.

I feel the hair on the back of my neck stand up as a guttural, growling sound emerges from somewhere in the darkened lodge. I try to see the sweat lodge leader across the fire pit.

"Are you okay?" I call to him.

Fear crawls into my throat as a deep, other-worldly voice snarls, "Go north and save my people."

I scream in panic to the Keeper of the Fire standing outside the sweat lodge, "Open the flap! Hurry!"

As light from the campfire and cold air flow in, the Medicine Man is on his hands and knees clawing at the frozen ground, his face pressed against the baking stones. I reach across the fire pit and grab his hair, pulling him up and away from the heat. Somebody gasps, "All my relations!" and we tumble out into the freezing night.

Two of us drag the ceremony leader into the cold, fresh air. He rises onto his hands and knees in the snow. He disgorges and retches, "Boy! That was a great sweat! My Grizzly Bear Spirit came to me and told me to go to Alaska." He reels to the nearby water tank, shatters the ice covering it with his elbows, and drops into the freezing water. (We later learn the wind chill factor that magical winter night was forty below zero.)

"Do we have to do that, too?" someone asks me.

"After he gets out," I reply. "The Medicine Man is always first."

My next sweat lodge experience was both unusual and strangely comfortable. This time the Medicine Man's wife, Tila Starhawk Donohue, in her own right a Medicine Woman, led the ceremonies. The attractive young woman is listless and exhausted and has come to join us to reflect and regenerate. Co-ed sweat lodge ceremonies are almost unheard of, but we are all family and will keep our undergarments on this time.

◇◇◇◇

The spring rains have been hungry. All about the turtle lodge, mud and small pools of cold water tell us an uncomfortable experience awaits. How will we ever get the campfire started? The wood is soaked; the fire pit has six inches of water in the bottom, with no dry kindling in sight. However, we go about our business: A layer of wood in the bottom barely sticking out of the muddy water. We have at least a dozen large gray lava rocks and a wood pile four feet high.

The Medicine Woman starts her prayer invocation and power songs. The Sweat Lodge leader follows with a litany of songs we have heard before. We join in, trying to ignore the cold rain and brisk evening wind. We hear a new chant—a different feeling to the preparation ceremony. I wonder if this is the influence of the woman, or because it will be so difficult to get a fire going this night.

Our Native Healer wears a special distinction called The Keeper of the Sacred Fire. Historically, this was one of the highest honors

bestowed upon a member of the Iroquois Nation of upstate New York. In every village a particular person, male or female, seemed to have a unique relationship with fire. This element was basic to the very survival of the First People, and the villager with this special gift was considered a Holy Person. The Keeper could always make a sacred fire, regardless of weather conditions or availability of combustibles.

We shall see.

All is in readiness. The Medicine Man approaches the eastern side of the wood pile still chanting and singing. Suddenly, sheets of rain fall from the night sky. Our hair hangs down our necks; cold streams flow down our bare shoulders. It's as if the elements themselves do not want us to sweat this night.

A bright flash! Tongues of flame begin crawling through the pile of soaked wood: once again two contradictory forces of nature—fire and water—contest with each other for dominion. Fire wins this time. Soon, the dark night brightens with the warmth of the happy blaze. Steam hisses. As if by magic, the drenching rains cease and stars peer out from the dwindling clouds.

Another hot sweat lodge experience.

As the glowing stones darken, Tila participates in the singing and chanting. How strange to hear a woman's voice in the eerie dimness of the sweat lodge. Despite the painful oppressiveness of the heat and steam, the ceremony has a sense of lightness or softness.

Then, the heart wrenching sounds of a woman crying.

A sea of sorrow seems to wash over me. Unexpectedly, I feel a warm, gentle embrace and hot tears on my bare chest and shoulders. I didn't realize I was sitting so close to the Medicine Woman, so I reach out to put an arm around her. But I am alone. She has intoned the weeping woman spirit to come to us. Because I am a man and have been taught to never cry for my own pain and sorrow, or for any reason, the weeping woman spirit did so. This is an ancient and sacred rite as old and as timeless as stones. The muffled sounds in the darkness of crying and sniffling tell me the spirit has found other men and boys to comfort this night. Even the Keeper of the Sacred Fire outside the lodge is crying.

A sense of relief washes away my despondency. I feel like soaring. I have a flying song that helps me participate in an out of body experience, sometimes called astral projection.

"Yah Kee Oh-Oh-Oh
Moh-zhah Nah-lay ... Ay
Peh-zheh Yah-kee-skay
Shah-nah-neek Nah-zhee ... Kay
Moh-zhah Nah-lay ..."

It feels good to sense the sounds falling off my tongue and over my
lips. As I repeat the chant again and again, the others begin to learn
the simple lyric and are singing with me—except Tila. In the dying glow
of the fire pit we see her unconscious and limp body reclining against
the interior wall of the lodge.

"All my relations..."

We gently remove her into the cold, wet air as the Medicine Man
begins the come back song and blows smoke in her face. Her spirit
had left her body and was soaring in delicious freedom. Soon, the
limpness leaves her body and she stands unaided. The anxious looks
of the others turn to relief as she smiles brightly and tells us of her trip
to Mount Shasta and the Trinity Alps near the coast of northwestern
California. We all chuckle at her child-like enthusiasm.

We shared special gifts that magical night. Tila brought the
weeping woman to us to ease our sorrow. My flying song allowed
her to release from her tired, ill body and find a special relief of her
own.

Sweat Lodges—A Historical Perspective

The origin of the sweat lodge or sweat house has been lost in the
farthest reaches of time. Two schools of thought as to what brought
them about seem reasonable explanations. Possibly, their original
use was for hygienic purposes. Native people were not always near
a lake or river where they could bathe and needed a portable way of
keeping their bodies clean and odor free. On the other hand, sweat
lodges might have served as mobile churches, offering privacy for
the most sacred rites and rituals. Many Indians were nomadic as
they traveled with the buffalo or moved their villages from summer
camp to winter camp. They couldn't build a permanent place for
worship, then leave it for half the year.

Regardless of the reason, many kinds of sweat lodges and sweat
houses existed, and all were considered sacred by the people.
Traditional Natives believed the lodge was a place where human

beings could reach toward the Great Spirit through preparation, prayer, song, cleansing, and penance. His power for healing and medicine could be requested and might be received on this Holy Ground if the people could make themselves worthy.

This phenomenon wasn't only found in the Western Hemisphere. Europeans used sweat houses for health and healing many generations before the influence of Christianity. Today's sauna and Finnish steam baths are remnants of a spiritual rite once used on the Continent as Traditional American Indian people still do today. The European lodges were centers for purification, doctoring, therapy, praying, training, vision seeking, guidance, medicine making, and physical and mental health.

Some Native people have temporary sweat lodges, while others construct more permanent structures, best described as sweat houses. The most familiar is the sweat house commonly associated with the Plains Tribes, but also used by groups such as the Eastern Woodlands, Great Lakes, Plateau, and Mountain societies, and a sampling of the Desert Southwest cultures. Called the turtle sweat lodge, it is constructed from willow saplings placed in a circular pattern, then bent over and tied to make a shape similar to an upside-down basket or turtle shell. In the early years this kind of sweat lodge was covered with tanned animal hides. Eastern Woodland and Great Lakes tribes used birch bark as coverings. Some of the Plateau and Desert tribal people covered their lodges with material made from hand-woven marsh reed mats. Others used branches, large chunks of cedar bark, and earthen materials—whatever they could find in their environment.

Today, almost anything can be used to encase the lodge. As you travel from village to village, you might find one covered with canvas or tarp. Another might have faded rugs or blankets and sleeping bags. The doorway always faces the East—except for the Sioux Nation. These north central plains tribes have their entrances face the West, because they believed that at one time the sun rose in the West and set in the East. Their prophets say this will happen again in the foreseeable future.

Cherokee people who originally lived in the southeastern part of the United States made their sweathouses from logs built in a hexagon shape, and then covered with mud, clay, roots, and tree saplings to create a low mound-type structure. It could be used for a dry sauna or steam sweat.

The Navajo tribe called their structures earth lodges and made them similar to, but smaller than, their ho-gans. Some mountain Native groups, like the Klamath Indians of southern Oregon used caves for their sweat ceremonies. The Indigenous People of northwestern California build lodges in the ground with planks of redwood or cedar. They are one of the few Native groups that have their doorways facing north.

A sweat lodge or sweat house was an important part of any Traditional Indian society and had other purposes besides communing with the Great Spirit. Sweats were often held to prepare hunters before they went after game. Heat and steam removed the man smell from the hunters, which improved their chances of getting close enough to kill the wary creatures that provided food for the village. Preparation ceremonies for war occurred in the sweat lodge as the warriors sought protective medicine. After the battle, warriors came to purify themselves and heal their wounds. The lodge might serve as a schoolhouse where young people learned about history, their heritage, language, culture, myths, and religion. Some communities used the lodge as a counseling center for group therapy, marriage and family problems, and general mental health issues. Most Traditional Native tribes saw the lodge as a church where people could congregate for spiritual pursuits.

The sweat lodge was universally used as a form of hospital. Native doctors sang power songs over their patients and used burning sage or cedar smoke to smudge the ill—believing the rising smoke cleansed the patient's aura and carried their prayers to the Great Creator. The practitioner knew which feathers and regalia to use for specific illnesses and applied this procedure as he or she bathed the sick person with herbs mixed in water.

The sweat lodge or sweat house is still used by Native American and non-Indian people who believe in its power. The miracles that have occurred in this setting are beyond count. But, like all good things, the lodge can be despoiled by those who feel it's a place for sexual acts or a location to create evil and bad medicine. The Creator-God has great power, but let us not underestimate the ability of The Imitator and his negative energy on those who walk this planet.

THE HIGH PLACE
Pah-ha'-ah-gon

The sweat lodge done ... I'm on my way.
My Vision Quest will start today.
Three days and nights to find the Truth.
The High Place calls to this Native youth.

The Shaman said, "Be still ... and strong.
The answers will not take too long.
I know you'll groan from Hunger's bite,
But show no fear ... You'll be alright."

"The animals will talk to you,
And tell you stories strange but true.
About your lives ... now and before,
And all the wonders still in store."

"So ... welcome to the family.
You shall be called Bumblebee
The creatures sing because you came.
Now the Creator knows your name."

Ha-Gue-A-Dees-Sas
2007

Bumblebee

Chapter 4
Vision Quests and Power Quests

What is a Vision Quest?

Throughout North America, Native men and women sought spiritual power through dreams, visions, sacred objects, and songs. At the time of puberty almost every Plains Indian boy set out on a Vision Quest— periodic wilderness retreats during which the initiate sought guidance from the spirit world. Only with the aid of special Power Beings—such as the spirits of eagles, hawks, or bears—could a person gain supernatural assistance for war, healing, love, or tribal leadership

Even today, a person (male or female, elderly or youthful) must participate in preliminary events

Owl

before the quest. Each must abstain from drugs and alcohol until the body has time to cleanse itself of these impurities. The Initiate who plans to spend time on Holy Ground must be acceptable to the Creator and the spirits residing there. Sexual activity weakens a person's energy, motivation, desire to grow spiritually, and striving (sometimes called the libido), so no sex for a length of time determined by the Medicine Person or Elder supervising the Vision Quest. A woman on her moon time (menstruation period) must wait until this has been completed. Fasting is an important aspect of preparation. The person planning to go on a Vision Quest should ingest only water for four to seven days. Some sort of corporal purification is

also a must. In the old days, and even now, an experience in the sweat lodge or sweat house meets this requirement. In a nutshell: He or she needs to get right.

After strenuous preparation, the initiate goes to a secluded location in hopes of receiving a vision, visitation, dream or special revelation. Normally, Vision Quest participants go to a high place, a secluded beach or forest, or a recognized sacred site. Many days may pass while the initiate awaits a supernatural occurrence. During this time, he or she must continue the regime of preparation; pray unceasingly to the Creator, the Earth Mother, the spirits and grandfathers; and creatures residing in that location. He or she must respect the Holy Ground and work hard to control mind and body.

After all this effort, a vision may or may not occur. If a vision does happen, the participant may not understand it or be allowed to share his experiences.

Vision Quests were, and are, an important rite of passage for adolescent male and female American Indians and Alaskan Natives who embrace the Old Ways. For these young people, it is a stepping through process from childhood to adulthood. These religious rituals also help Native Healers and Medicine Men and Women increase their psychic abilities.

What is a Power Quest?

As with a Vision quest, someone who wishes to participate in a power quest must go through the challenging rituals listed above, including preparation, fasting, training, deprivation, cleansing, and strenuous activity.

However, the goal of this hard work and dedication is completely different. Young men go on power quests to become great warriors, to train for bravery and courage, or gain physical coordination and stamina for ritual dancing and powwow competitions. Young women seek power centers or sequester themselves in moon-time lodges to become seers or healers, or find love power. People may wish to gain gambling power, good luck, or wealth. Athletes search for the sacred power centers to gain strength and agility. Native people go to certain places to train for protection or long life. Other places are designated doctor training grounds where people go to become healers and learn to care for others mentally and physically.

As with vision quests, the initiate may prepare properly, do everything correctly, and still not receive the power being sought.

They may have had selfish motivation or intended to do harm with their new powers. As a backlash, they might get just what they deserve—or the Great Creator may give them what they need rather than what they want.

Power centers can be found by talking to others who've gone on power quests, by learning from local Native elders, and by reading myths, legends, and written histories of certain tribes. Sometimes a power center is found without any tangible explanation. While exploring the wild mountainous country of northeastern Washington State, I stumbled across the actual Thunder Mountain of the Kalispel Tribe, where Holy Men had gone for generations to train and meditate. I honestly don't know how I did it. I was somehow led to that location.

The High Place Speaks

Brightly colored fabric rippled in the bone chilling breeze: Red, yellow, black, white, blue—eight foot long and a half-foot wide ribbons of sail cloth fought with the juniper bushes and the tangled knot restricting their freedom. Despite the gloomy late afternoon in the Big Horn Mountains of Wyoming, the strands of cloth danced and twisted in a strangely gay profusion; as if alive. A rainbow of colors cheerful and vibrant, they contrasted the dull earth tones. I had no doubt this was the place.

Had I continued living with the people on Yakama Indian land of Washington State or in the Black Hills of South Dakota, I would have practiced this ritual, called a Vision Quest, during my early teen years. Now, as an overweight 50 year-old who'd lived the soft life for at least 30 of those years, I wasn't looking forward to the regimen.

Where would I go? A high place?

Some years before, Medicine Grizzly Bear Lake had asked me to carry a revelation to the spiritual leader of the Macah Indians living on the western tip of the Olympic Peninsula of Washington State. A grandfather came to him while in a reverie and repeated three times: "Neah Bay is going under ..." Bear did not even know where Neah Bay was. I had been to this interesting Native village on the Straits of Juan de Fuca and knew medicine man Ron Johnson well enough to share the message with him.

While I conveyed the warning to Ron and discussed its implications, a rain squall blew over us. As it passed, hundreds of black crows and ravens flew in and landed in the trees, on the eaves

of nearby homes, and in the fields around us. They strutted and squawked comically: Large black glistening birds with clear eyes and strong voices. I said we believe Ravens and Crows are Holy and can bring messages of both hope and impending doom. Ron said he was aware of that belief, but the Macah's messengers are sea lions.

I asked if he had any prophecies for me. The Macah medicine man looked into my eyes, then said: "Look to the north. Let the rains wash across your face. And be sure you are right, then go ahead."

"Look to the north."

Did this imply I should go to Alaska or Canada for my vision quest? My father came from the Blood Tribe country of central Alberta. I have sometimes felt a calling from that place.

The Medicine Man saw the confusion on my face. As we walked together, he began to speak. "At one time, every tribe and band had sacred sites. Often they were high places, caves, waterfalls, secret parts of the forest, or unusual geographical features. They were considered power centers and special places for religious ceremonies, burials, training and vision quests. Some were so sacred that only Holy people could go there. Some so special that intricate ceremonies and rites had to be performed before entry could occur. All were marked or posted in some fashion to alert others to stay away. When the Euro-Americans came, not only did they defile these sacred sites, they often stole the markers. Today, many of the Holy places are lost, or the people have been forced to move away from them. They will never be able to find themselves spiritually until they can return to their own sacred places. I think you should go to the Medicine Wheel."

"Never heard of it."

"It's in the Big Horn Mountains east of Yellowstone Park in Wyoming."

"I'll think about it. That's a long way from the Pacific Northwest. Are there any closer places you can think of?"

No comment.

I was beginning to get the picture. No part of a vision quest is supposed to be convenient or easy for the acolyte.

My Triple A road map of Wyoming showed the Medicine Wheel on Medicine Mountain at almost 10,000 feet of altitude, in the middle of nowhere. I needed a safety net. Help would be too far away if I became injured or debilitated. I was willing to seek a vision, but I didn't want it to be a terminal activity. I called my high school friend

Adam, who lived in Gillette, Wyoming. Yes, he would be able to join me. He'd always wanted to explore the Medicine Wheel. He knew the rituals involving a vision quest and was willing to help.

I was approaching a profound spiritual crossroad that would change the direction of my life. I had to prepare myself mentally, emotionally, and physically for the travail that loomed on the horizon. In the traditional Native American world, the sweat lodge is the vehicle that best serves this purpose, so I contacted Medicine Grizzly Bear and requested he prepare the sacred ritual procedures.

The ceremony of purification in the turtle sweat lodge was exceptionally hot and oppressive. I had been in other sweat lodge rituals, but never one so profound. The herbs and water hit the glowing lava rocks and splattered all over me … superheated. I gasped with pain as blisters formed on my bare arms and shoulders.

"You'll need to be clean so the spirits will accept you. They are powerful. They could hurt you, even kill you," the Medicine Man informed me. "You need to be acceptable in the Creator's eyes."

I could not endure any more. I choked out the words of exit: "All my relations … please accept me into the Circle of Life!"

It was good to get out of the lodge, into the night air and the cold pond where we immersed ourselves. This one was a real pressure cooker. I felt weak and disoriented. My knees were rubbery and my breath didn't satisfy the strangulated feeling in my throat and chest. The stars blurred and shimmered. My head ached.

I stopped eating after supper that Sunday night. Until the fire ceremony the following Saturday evening, I would ingest only distilled water. Some ceremonial fasts involve drinking juices and teas as well. The elders say water-only fasts weaken the psychic powers in a person. I was determined to do this the most difficult way. It had become a personal challenge.

"You will experience considerable discomfort in a day or two," explained Medicine Grizzly Bear. "If you can keep from eating during that time, your body will begin moving upward to the second plateau and start living off its own body fat. You need to advance to the third level to be in the proper state for your vision. Push yourself."

My friend and I left from his home and arrived at the Medicine Wheel midday on Wednesday. Though it was mid-August, the constant wind felt biting and unwelcoming toward strangers. Grey, angry clouds marched eastward, unhampered by the snow-capped peaks around us. Spattering drops of rain left muddy footprints on

my truck's windscreen. Occasional flashes of lightning and menacing thunder rolled in from the west. This did not bode well.

Leaving the main highway, we followed a dirt and gravel road that clung precariously to the side of the ridge. It twisted and wound upward and northward over the top of the mountain. My anticipation heightened as I tried to picture in my mind what we would soon see. Once I decided to do my vision quest there, I read magazine articles on the setting and its mysteries. I envisioned some kind of Native American Stonehenge awaiting me.

What a shock! Before me, a barbed wire fence completely encircled what was left of the Medicine Wheel. Over the years, people had been stealing stones from the circular rock walls and the spokes of rock rows that radiated toward the center altar. Other cairns of rocks marking a line with the summer solstice sunrise and sunset had been disturbed so much they were barely perceptible above ground-level. Litter blew everywhere and piled in drifts against the fencing. To the north of the Wheel, a modern stone toilet has been constructed. Off to the south of this sacred site, a huge air-traffic control radar dome hummed angrily—a constant reminder to the spirits of the mountain that the White Man and his machines now ruled the earth.

Tears welled up in my eyes as I stumbled from the truck. A handful of cars and R.V.'s were parked helter-skelter, with people grinding their camcorders and clicking their camera phones. Laughter and loose chatter interrupted the silence of this ancient place. Somebody's dog sniffed at a fence pole, preparing to lift his leg in desecration.

"What's the matter with you?" I shouted. "Look what you've done to their church!"

One of the tourists turned and glared at me over his shoulder.

I scanned the barrier, trying to comprehend the incredible sight. The cruel wire and mean barbs mocked years of tradition and respect. Then, as I glanced toward the east, I saw medicine bundles, tobacco ties, feathers, bits of ribbon and colorful cloth attached to the barbed wire. Indian people honored this place with their prayer-ties, despite the sacrilege. How appropriate. Before me in a simple microcosm was a parable of the relationship between the Indigenous Peoples of this continent and their oppressors. All I could do was look away.

A rutted dirt road led north along the ridge, away from the Wheel. We traveled about a mile to a grove of juniper bushes and began setting up camp. No people here, just brightly colored strands of cloth whipping in the stiff breeze. Indeed, this was the place.

My friend knew I had to work myself toward exhaustion. He pushed me.

He tested me each day. He noticed I wasn't tiring, despite the lack of food. We hiked, explored, went fishing, and climbed. Each day was active and demanding—but I kept up. He checked my eyes.

He teased me at meal time: The camp stove warmed his sumptuous meal of corn ears, baked potatoes, steak, bacon and eggs, pancakes, donuts. I kept drinking my water. The aromas were heavenly.

Nights became fitful, thanks to the dull ache in my stomach. So this was the emptiness millions of people across the earth experienced every night of their lives.

I awakened in the dark night and found him bent over me, listening to my breathing. No problems. I playfully implied he was some kind of pervert. We played rock n' roll trivia on into the night.

The winds blew, flapping against our tent.

I rose before sunrise. The Dakotah Sioux call the sun WE. The red fireball slowly climbed above the eastern mountain range—giving us a break in the cloudy weather. I sang my good morning song. The day was bitter cold, but glorious. I had reached the second plateau. In time, the dull throbbing ceased. Where was the euphoria and the sense of being separated from the tangible world? No symptoms.

The day left us and darkness walked across the landscape. There were no lights, no motors, no sign Mankind was nearby. I felt vulnerable and lonely despite the companionship of my friend.

That night the Great Horned Owls came ... silent and angry. We were in their hunting grounds. I felt them in the darkness of each night long before our campfire reflected their baleful yellow eyes. They circled. They hunted. They patrolled. Each night, voiceless, but speaking to us in disapproval, "Two-leggeds, you have done enough to our earth. Hunting is hard. You have killed or frightened away our prey. Leave us ... leave us ..."

The winds blew.

The next afternoon the blood-red sun caressed the ragged mountain ranges to the west as we began preparation for the Saturday evening ceremonial fire. On the morrow we would leave the mountain top and return to reality. Last chance.

We cleaned out the fire pit, placing burnt cans and other refuse into a plastic bag. I rolled the first of several heavy rocks toward the fire area.

"What are you doing?" my friend inquired.

"I'm putting large stones around the fire for the Grandfathers to sit on. I want them to feel welcome around our warm fire."

"I'll help you. How many?"

"One for each of the Sacred Directions, plus Father Sky and Mother Earth. Six in all."

We stacked twigs, limbs, roots, moss, leaves, and parts of small bushes to construct the fire. No chemicals, starting fluids, metals, or plastics—everything had to be natural. If I could start a fire without matches, I would. I hoped the spirits understood.

The weather turned colder and I smelled moisture on the wind again. A giant cloudbank approached from the north. Gray fingers tinged with red from the disappearing sun reached out to claim the clear evening sky. A few stars briefly appeared as if to say, "Goodbye. You will not see us much longer."

Darkness arrived.

I sat facing the east; my friend the north. Despite the cold and dampness, the fire burst forth, laughing at the night and touching us with its warm breath.

I introduced myself in the correct manner and began sprinkling tobacco into the flames:

> *"Great Creator, Mother Earth, and all my relations ... My name is Stan Hughes, my Indian name is Ha-Gue-A-Dees-Sas. I come from Yakama Indian country. My race is part White and part Native; my nationality is American; and this is why I am here: I am here on a vision quest. According to ancient customs and law, I feed you tobacco ..."*

We chanted an intonation of invitation to the Oo-kon'-nah-peh, the Grandfather Spirits:

> *"Grandfather Spirits who live in this place, please join us and warm yourselves around our fire. We have placed stones so you do not have to sit on the wet earth. We welcome your companionship and ask for your help and protection. We offer these gifts to you ..."*

The litany continued:

> *"...Sagebrush, tobacco, cedar ... We honor the directions— East, South, West and North. We acknowledge Ah-teh' mah-pe'-yah, (Father Sky) and E-nah' man-koh'-chay, (Mother Earth)."*

As I reached into the paper grocery bags of aromatic plants, I pulled out a cloth scroll wrapped in gold ribbon. In the firelight I saw it was a letter from my little girl to the Children Spirits. A gift for the fire; a special touch for this magical night. We waited... expectantly ... patiently ... we humbled ourselves and chanted our prayers of penitence. The Medicine Grizzly Bear calls it Peh-ga'-soy.

We waited and the fire became glowing coals. The mean wind whispered in my ears, "No visions ... no magic ... no nothing ... l-o-o-o-ser."

A cold drizzle fell on Sunday morning as we silently broke camp. The sun walked somewhere above the clouds, but there was no warmth around me. I no longer wondered why the earth was so barren on this ridge. The stunted juniper bushes seemed able to resist the harshness of their environment. Here and there, tufts of lodge grass clung to the sparse earth behind piles of stones. What a strange place to construct a Medicine Wheel. Nobody would come up here... Maybe that was the reason.

The bright fabrics rippled in the cold breeze. Sacred colors: Red, yellow, black, white and blue. Indian people tied them there as a thanksgiving offering for allowing them to camp and pray. We left food and poured tea into the earth, threw tobacco into the wind. It was not much payment for spending four days on Holy Ground.

The return trip was silent—even pensive. Finally we shared our disappointment: The rigors and commitment, the proper attitude, the expectations, the correctness of the ceremonies—but no visions.

We don't know when we'll be able to find the time again.

Reflections Concerning Vision Quests and Power Quests

It is not just a Native American ritual for people to seek out the "High Places" in hopes of receiving visions or revelations. Even Judeo-Christian history mentions many examples of this:

> *"Moses was summoned to the wild lands of Mt. Sinai to receive God's message: For they were departed from Rephidim, and were come to the desert of Sinai, and had pitched in the wilderness; and there Israel camped before the mount. And Moses went up unto God, and the Lord called unto him out of the mountain ..."*

Exodus 19:2-3

Jesus was baptized by John the Baptist, and then led by the spirit into the wilderness:

> *"Then was Jesus led up of the spirit into the wilderness to be tempted of the devil. And when he had fasted forty days and forty nights, he was afterward and hungered."*
>
> *Matthew 4:1-2*

Saint John was banished to the secluded island of Patmos in the eastern Mediterranean Sea, where he received Revelation from God:

> *"I, John ... was in the isle that is called Patmos, for the word of God and for the testimony of Jesus Christ ... and heard behind me a great voice, as a trumpet, saying, "I am the Alpha and Omega, the first and the last ..."*
>
> *Revelation 1-9-11*

In the 1850s, Chief Crazy Horse professed the value of seeking visions to find out who we are and why we are on the earth:

"A very good vision is needed for life, and the man who has it must follow it — as the eagle seeks the deepest blue of the sky."

In the 1990s, Medicine Grizzly Bear wrote this clarification:

"In order to have a vision, we must turn to the Great Creator, Mother Earth, and our relations in Nature. We must enter the dream world and the deeper levels of our own mind, to the ancient archetypal images in our unconscious, to our very soul. We need a vision in order to guide us through life, to give meaning to our life, to give us strength and protection, and to find answers to those mysterious questions and experiences that plague our life with pain and suffering."

Whether you are intend to go on a Vision Quest or Power Quest, the process is the same. You must prepare yourself in the right and proper way. You must expect a degree of suffering, deprivation, and sacrifice to prove you are worthy to go to the high places. If you take on this difficult process with a negative attitude or in hope of gaining power to hurt people who have hurt you in your past, then go no further.

The true danger in this rigorous endeavor is finding answers to the questions you have always been afraid to ask:

"Great Creator, Mother Earth, and all my relations:

Who am I, really?

Who is the true ME inside?

Where did I come from and where am I going?"

Why am I here? What is my purpose and function in life?"
What do you want me to do?"
What do you want me to become?"

The answers can reveal themselves in many ways. Animals might come and communicate with you in your solitude in the high places. I've been told they actually talk to you, but you must never share what they say, or they will not come back.

You might have contact on a spiritual level through an awakening in your heart and newfound knowledge washing over you. A school of thought called genetic memory professes that lessons learned in prior lives reside deep in our genes. Only a difficult, and life-changing event will bring them out—like a vision quest. You may already have the knowledge and power you seek, waiting to reveal itself.

On occasion, the Great Spirit may choose to speak directly. Bible prophets like Moses aren't the only humans God has conversed with. Prayer is a super highway between Man and the Creator, and this can be a two-way street if you ask for the blessings you seek and remain open to revelations. Mother Earth loves her Two-leggeds and continually reaches out to them. She may endeavor to touch you through signs in nature, but you must watch for them.

If you are becoming a native healer, plants and herbs for your work may suddenly become recognizable and you will have an unexpected penchants for knowing which to use. Medicine Grizzly Bear told me of the time he was trying to find Icnish root (also called Grizzly Bear root or Angelica) for doctoring purposes. He saw a large plant on a hillside and wondered how he could ever get it out of the ground. He pulled on it, hoping part of it would break free, and the entire plant, roots and all, came out of the soil with almost no effort. He felt the plant gladly gave its life for human purposes. There are reported cases where sacred birds, like eagles and ravens, fly up to a person and shake off tail feathers for use in sacred ceremonies.

Most difficult to explain of all: As a result of your hard work, determination, and proper attitude, the Great Spirit and your Human Spirit may finally come into congruence with each other to the point that you just know what is right and how to do it. These changes in you will be validated by the Medicine Man, Woman, or Elder mentoring your progress.

◊ ◊ ◊

ASHES
Cha-go'-tah

Once the center of all I could see.
Everyone came and stood around me.

The warmth I gave off made them all smile.
Happy to sit and visit awhile.

The light of their lives—that is no doubt,
Then no one fed me ... and I went out.

So cold and dark grey ... now, I'm just here.
Brittle and dry. I can't even tear.

... Time passes ...

Someone is coming. I hear her sing.
She stacks the wood and fills up my ring.

Small precious flame and I start to glow.
My light and my warmth begin to flow.

Now the center of all I can see.
Everyone comes and stands around me.

Ha-Gue-A-Dees-Sas
2007

Chapter 5
Chant of the Medicine People

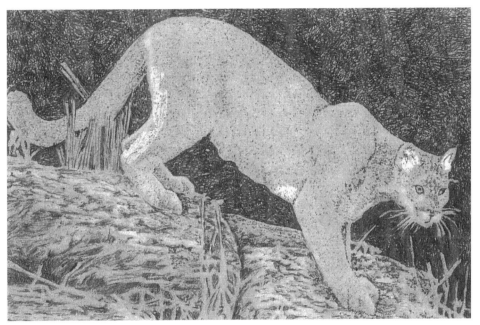

Cougar

I watched the Native Elder preparing to teach my children the knowledge passed down through hundreds of generations. I wondered if my small ones would comprehend the value of this information and the timeless process used by Elders beyond memory to pass the tribal heart to another generation. Raised in a society dominated by the printed word and electronic media, I feared my children wouldn't respond to the simplicity of the spoken word.

◊◊◊◊

"Traditional Indian people believe thirteen is a sacred number," the medicine man said. "If you ask a child raised and educated among The People instead of in a White Man's school how many months are in a year, that child will answer thirteen. You see, there are thirteen full

moons in an Indian year, and we call our months moons. When one of the full moons occurs in the same White Man's calendar month as another full moon, the second is called a blue moon. Each month has a special name. Teddy, you were born in June. Your month is called the Moon of the Salmon's Return. Cathryn, you were born in October. You're month is called the Moon of Falling Leaves. I was born in January, which is called the Moon of Crackling Branches.

"Native people had no telescopes or other scientific equipment, but they knew our solar system has thirteen planets. You wait and see. Someday this will be proven scientifically. A perfectly balanced eagle will have thirteen tail feathers, and these are the most powerful birds for ceremonies and healing."

◇◇◇◇

As the lesson continued, my children seemed almost hypnotized by the rhythm and sound of his voice. I found myself swept away by the magic of the moment, as though I lived a long ago time, sitting at the knee of a spiritual leader.

He reached under his ribbon shirt and pulled out three medicine wheels made of plant fiber and colorful thread, each the size of the palm of his hand and tied to a leather thong necklace.

◇◇◇◇

"The medicine wheel is divided into four parts," he continued. "This helps us remember the Four Sacred Colors—Red, Yellow, White, and Black. Some tribes may exchange one of the colors for Blue or Green. Usually Black is the one not on their hoops. When I was in Japan, I doctored some Shinto Holy People and learned they have four sacred colors also—Red, Yellow, White and Blue"

◇◇◇◇

He continued his lesson, speaking of Earth Mother and how we must care for her. He said all living things are in relationship with each other and the human persona has four levels of existence. Everything is a Circle.

Then he stopped and looked deeply into the eyes of both children. They were completely enthralled. Then, to our surprise, he snapped one of the medicine wheels in half. The crack sounded like a rifle shot in the quiet darkness.

◇◇◇◇

"The Sacred Circle has been broken."

◇◇◇◇

His lamentations about the plight of the American Indian and Alaskan Native, both historically and currently, brought us to tears. Then he said kindly, "That's enough for tonight. You have much to learn, but you have already learned much. Now is the time for thinking."

What is Shamanism?

Is the practice of shamanism a religion, a cult, an oppressive series of actions based on fear, or pagan rituals that flaunt the true church? Traditional Native Healer, Medicine Grizzly Bear Lake, son of Karuk Tribal Medicine Man, Charles Red Hawk Thom of northwestern California, makes these distinctions:

It is difficult to come up with a definition of Shamanism that's acceptable to all people and also intelligible to the everyday reader. Shamanism is an extremely complex cultural function which can be interpreted from various viewpoints. Some of these points are unfair as well as inaccurate, thus requiring clarification and modification. For example, in past and present literature, the shaman is identified as a magician, conjurer, occultist, pagan, witchdoctor, and similar derogatory types of descriptions. This is especially predominant in sectarian writings.

While the above descriptions may apply to a few imitators who claim to be shamans, it certainly doesn't fit the true medicine people, or all native healers. The shaman is a highly specialized medical and religious practitioner who, in most situations, is born with extraordinary power, clairvoyant abilities, natural healing talents, and an exceptional intellect which has been developed through studying specific bodies of knowledge and doctrines. Such doctrines include ancient myths, symbols, and rituals that have walked the Earth for many generations.

Shamans held great power and influence in their communities. The term Shaman in these writings will be interchanged with Medicine Person or Native Healer. These Holy People were honored, respected, cared for—and feared. A Medicine Person could be male or female, or a Hey-yo'-kah, someone whose attitude, behavior, and personal appearance was so foreign to the norm that his or her gender was anyone's guess. Interestingly, some Native Medicine People in tribes and villages might today be described homosexual or transgender. These man-woman or woman-man people were

called Wink'-dah by the Sioux people.

A Medicine Person might be a physician, a psychiatrist, a priest or preacher, a mythologist or mystic, an advisor, a teacher, or even a sorcerer. Most often, he or she was a combination of the above. How the Native Healer served the people depended on his or her knowledge, power, ability, experience, training, and actual function within the culture. Some were more involved in healing, while others were ceremonial leaders and ritualistic performers. Regardless of their actual responsibilities, they always played a significant role in the physical, mental, and spiritual health of the village.

A Child Called by the Great Spirit

The tribes knew a child destined to become a Shaman or Medicine Person demonstrated special characteristics and abilities from a young age—especially care, respect, and unconditional love toward others. Such a special child might have been raised by the Elders, or could be found in their presence (even underfoot) asking questions and trying to relate to them. The novitiate had an unwavering trust in the Elders and believed their influence and experiences would be instrumental in his or her spiritual development. In response, experienced Medicine People or tribal elders would isolate the gifted child to develop the spiritual gifts. The Elders served as a buffer between these special children and distractions from the outside world.

The future Healer might display a unique ability to remember and understand tribal songs and stories. Young men training to be Tribal leaders for the Swinomish Tribe of Washington's Puget Sound area went into solitude in the snow covered Cascade Mountains until they received their "song" in a dream or vision. At the next potlatch (celebration) in the Long House, they would sing their song to the people. My friend, Robert Joe, brought his song back from his Vision Quest and sang it to the people. Some of the oldest women began to cry, because the song was the same as his great grandfather's, who died years before Robert was born.

Powerful dreams, visions, and even visitations occurred to these future tribal leaders. When the child described one of these experiences to the Elders, they recognized the time-honored images from past communication between the Spirit World and the tribe by other Holy People. Often, the future Medicine Person had no prior knowledge of these images and was awed, and even frightened, by

them. The initiate would see and hear things other people could not, and had interactions with spirits, angels, or ghosts. An unmistakable calling to pursue the walk of the Holy Person would come to the child during one of these dreams or visions. This usually occurred as the child reached puberty, but could happen at an earlier age.

Fledgling Medicine People lived and felt close to nature, with an understanding of the special relationship between the Two-leggeds, the Four-leggeds, the Flyers, and the Swimmers. They seemed to have a way with animals and might claim they could talk with them. They might be seen walking with the animals. Young Native Healers had an innate understanding of plants and herbs. They could naturally learn to identify, store, and use these pharmaceuticals.

Blood, Sweat, and Tears—Medicine Training

Medicine People know that those who become legitimate Holy People are predestined for this role. The Creator God knows us before we're born and selects certain beings to carry on the works of His spirit. In Asian societies, a Chosen One is recognized and guided down the mystical pathway to Spiritual Leadership. This practice is similar in American Indian and Alaskan Native cultures.

Some begin the walk toward Medicine at an early age, but the man or woman who strives to achieve his or her Healer destiny later in life is not lessened because of this. In both cases, the novitiate faces a long, arduous trail of training, testing, sacrifice, suffering, learning, and constant evaluation by the Elders and teachers before becoming qualified to actually practice this profession. The true Native Healer is spiritually and culturally selected through inheritance or a psychic calling, such as a dream or vision That is only the first of many difficult steps.

Those who are in line to become Medicine People through inheritance, but do not demonstrate the needed potential, desire, or spiritual qualities aren't allowed to reach a leadership position. In some cases, these potential leaders terminate the training on their own. This is a world of free will, and a Chosen One may choose to not be chosen. A close friend of mine was destined to be a Medicine Man for his clan on the Yakama Indian Reservation in Washington State, through inheritance from his grandparents. The regalia and trappings to become a Holy Man are stored in his closet, yet he decided to not take the walk to Medicine. Surprised someone would turn down such an honor, I asked him to explain. His answer chilled

me: He knew how powerful he would become after the training. He told me he held grudges against people who'd harmed him personally or professionally over the years and didn't have a strong enough character to avoid using his medicine against those who wronged him.

After the calling, then comes an initiation process into becoming a Medicine Person. One of the most unusual initiations I discovered for an adult seeker involved a near-death or actual clinical death experience. To a lesser degree, but equally significant, the novitiate might sustain a serious injury, contract a critical illness, or experience a life-changing accident or bout with mental illness.

The next obstacle toward the goal is no less arduous: The Vision Quest or Power Quest looms ahead on the pathway. As explained earlier, this ancient ritual begins with a cleansing in the sweat lodge, a physically and emotionally painful situation where the initiate is bathed in blistering hot steam in a claustrophobic setting. The participants do indeed sweat profusely, allowing toxins and poisons in the body to seep out and to be steamed away. The Native Healer prays and sings to the Creator God, asking that He send his protection and strength to the person in training. This event may last many hours until the future Medicine Person has a vision, faints, or cannot endure the pain for one second longer and tumbles out of the lodge into the cool air.

Then come days of fasting, deprivation, praying, and isolation. The neophyte is endeavoring to receive a vision, visitation, or other divine guidance concerning what he should do for his people. In the Sioux Nation, after a full day in the sweat house, the fledgling is placed in a hide-covered Vision Quest pit from one to four days. Some tribes take the future Native Healer to a sacred high place or power center and leave him or her in total isolation, without food or water, for at least four days.

Some northern California tribes put the initiate through the roughest of all initiation processes. For a period of five to ten days, depending on the wishes of the Elders, the person must not eat, must engage in repeated sweat lodge experiences, must pray unceasingly, and learn the religious rituals and truths of the tribe before participating in a Vision Quest or Power Quest. Once this ordeal is underway, he or she cannot come back to the village until a vision or special power has been received. Upon returning, another five to ten days of sweating, fasting, singing and purification ceremonies

await the exhausted participant. This final process serves as a means to cook and synthesize their newly acquired powers and knowledge.

And the process still isn't over. Each stage weeds out the unworthy; some decide the price is too high. Once the neophyte has met the above criteria, an evaluation is conducted by hereditary headmen, older Medicine People, family members and a variety of tribal religious leaders from other villages and communities. The participant is truly under a microscope, being observed and questioned carefully to determine growth and potential. Should the future Medicine Person pass these tests, the final two stages of the training process will occur: apprenticeship and later, private practice. An older Indian Doctor called a Peh-Zhu'-tah We-cha-sh'dah in the Sioux tongue, guides the intern by example, teaching, and providing opportunities to use his or her new abilities under strict supervision. This apprenticeship could last two years or twenty years, depending on the learner's power, ability, aspirations, and competency.

The process of becoming a Medicine Person was, and still is, arduous and painful. Anyone who successfully meets the demands of this path is a new person physically, emotionally, mentally, and spiritually. Traditional Indian cultures valued their Native Healers above all else, and these men and women were truly worthy of respect, appreciation, and adoration.

THE PROMISE
Wah-ho'-yah

My Child ... This advice you must heed.
Please never take more than you need.
Promise to do these things I say,
I'll care for you in every way.

In Spring ... I'll make the grasses grow.
I'll sing to call the Buffalo.
As Summer walks the waking lands.
I'll pull the Roots with my own hands.

Red Berries sweet will paint the Fall.
The Deer will answer to my call.
When Winter comes, it will be mild.
These things I promise you, My Child.

Choose NOT to honor my request
You'll always wander in your quest.
Seeking, not finding your true home.
Lost nomads, empty and alone.

Ha-Gue-A-Dees-Sas
2007

Chapter 6
The Sacred Pipe

The Broken Pipe

Ceremonial Pipe

Medicine Grizzly Bear's young son Wind Wolf was deathly ill. Only six years old, this frail child's fever was so high he was convulsing and drifting into periods of unconsciousness. The emergency room personnel at the local hospital couldn't determine the reason and worked frantically to keep his temperature in check while waiting for a specialist doctor to fly in from Seattle to diagnose the illness. They gently packed him in mountains of ice bags. The Medicine Man was in great fear for the life of his son. He prayed unceasingly and had a frightening vision of sorcerers and witch doctors digging up family burial grounds to burn human bones in a cave. He was convinced this was a direct assault by evil spirits on the lineage of his wife, a traditional tribal leader and Indian doctor.

He needed the strength of a high place and stronger power, so he entreated me to drive him to the foothills of northern California's Mt. Shasta. Dominating the eastern horizon, this massive monolith is a power center and object of reverence and devotion to the local Native tribes. I honored his request without question.

We let his wife know our plan and headed into the moonlight. When we arrived at our destination, Bear wandered into the forest, singing and chanting the ancient sacred healing songs. I felt a deep stirring in my heart as the words and music wove among the stones and trees. All this was of the Earth.

He broke off his sonata and asked me in desperation, "Did you bring your pipe? The spirits are telling me I have to make smoke!"

"Yes. It's in my medicine bag."

A Holy Man had given me an old and precious medicine pipe. It was a gray stone bowl without a stem, deeply tobacco stained from ages of use in sacred ceremonies. I kept it wrapped in white deerskin and carried it in a rough, handspun wool purse given me by Thomas Banyaca, the keeper of the Hopi prophecies.

He loaded my pipe with tobacco, then resumed his song and walked back into the forest. I followed at a respectful distance and watched him climb over a small rock ledge and scramble down the adjacent hillside. Then I heard the most painful, heart-wrenching moan. In fear for his safety, I ran to the rocks and peered into the moonlit depression. He was on his knees in the dry earth, hands apart, looking skyward in total anguish.

"Are you all right? What happened?"

"I broke your pipe in two!"

He held a piece in each hand, tears streaming down his cheeks. "This is a terrible, terrible sign."

I tried to console him: I could repair the pipe … I never used it anyway … It would be fine… This was an accident … A little Super Glue, and all would be well. My words fell on deaf ears as he held the shards against his chest and was lost in prayer.

"We've got to bury the pieces! Here, in this place!"

"What? Do you know what you're saying?"

"The mountain said She will accept the pipe and send her power to help Wind Wolf."

I was flooded with mixed feelings. I didn't deny the sincerity of his statement, but this was my beloved pipe! More than that, it was a special gift from an exalted person. Even broken, it had value to me as a precious artifact and collectible. Something to keep in the family.

"We've got to dig a hole and bury it."

The ground was hard as concrete. Years of northern California drought didn't make the earth easy to work with, and a person doesn't necessarily have a pick and shovel in his vehicle. Thoughts raced through my mind: Would a jack handle work?

He began kicking at larger stones and the hard ground. "Find something to dig with!"

Despite my misgivings, I turned to comply.

"Wait! We're okay. Look!"

Beneath a stone he'd kicked over was a small opening—possibly an old tunnel entrance for a ground squirrel or snake. The pieces of my medicine pipe fit easily into the gap and could be pushed well below ground level. He covered the opening with dry earth, sprinkled tobacco on it as an offering, and then replaced the rock. He stood to face the Holy Mountain, lit the end of a piece of Icnish (Grizzly Bear root or Angelica), and sang his Mt. Shasta prayer song. Within minutes, huge, dark clouds shaped like bears began gathering over the crest of the snow covered peak. Then lightning and thunder roared and seemed to move rapidly northward. Unsure what was happening, I felt regret knowing I would never have a pipe again, and wondering what this had to do with the illness of his son.

Later, we found that Wind Wolf's fever broke the same instant my pipe snapped in half. We found him recovering in his hospital bed. Strangely, lightning and thunder and a driving hailstorm raged for over an hour—but only over the area around the hospital.

A Precious Gift

I eventually resigned myself to the fact that one of the most important pieces of my Native American collection was languishing in a hole somewhere in northern California. Months later, I was having lunch with my spiritual advisor and wife of Medicine Grizzly Bear, Tila Starhawk Donohue, in a metropolitan fast food restaurant. Two Indian men came in: Tired looking, unkempt, and smelling of diesel fumes. I found out they'd been riding a freight train in an effort to reach warm weather before the winter set in. I felt compassion for their plight, so when they returned, I struck up a conversation with them, much to Tila's discomfort.

As they turned toward the door, I asked if I could give them a donation to help as they continued their journey. They gratefully accepted the money and inquired if there was a mini-market nearby where they could buy food for the road. The larger man turned back to me, and with soiled hands and dirt-filled nails, made a bridge with his fingers, reached over and held them near me, smiled, and said simply, "What goes around … comes around."

I mulled over his comment, and wondered what it had to do with anything. I soon found out.

Later that year, in a modern hotel room in the Chicago area, I received my new pipe. During a conference, I met an Ah-oh-ze' (part Indian in Dakotah Sioux like me) from the Upper Peninsula of

Michigan. His name was Loren Woerpel, and we naturally gravitated toward each other from the first moment. We were soon talking like brothers and sharing Native American justice issues. I didn't realize how the loss of my pipe remained with me until that topic emerged as part of the conversation.

He invited me to join him in his room, and when we sat, he unfolded a small buckskin blanket and placed two items wrapped in white leather on top. "I knew these were for you as soon as we chatted about your ceremonial pipe being broken," he stated.

He motioned me to untie the leather pipe bags. One held a rose and ivory colored pipestone bowl, and in the other lay a beaded, hand-carved wooden pipe stem. Two turtles facing each were crafted at the bowl end of the stem. This was truly a magnificent work of art.

"I made the pipe," Loren commented. "In fact, I have three pipes and knew I had to do something with this one. That's why I brought it along."

Carved and sanded smooth, the bowl was made of stone from the Pipestone National Monument in southwestern Minnesota. The stem was constructed and hollowed-out from a single tree branch, expertly handcrafted in every way. I was deeply touched by his gesture and vowed to honor the pipe for the rest of my life before passing it on to my son at the appropriate time.

According to tradition, the next step for the pipe was having it blessed and consecrated to the Creator, a required and time-honored validation procedure. How could this be arranged? While attending another conference at the Warm Springs Indian Reservation in central Oregon, I was able to contact one of the Confederated Tribe's Chiefs, Delvis Heath. Early one morning, facing the rising sun, Chief Heath, a vital and energetic elder with a special spark in his eyes, blessed my pipe and presented it to the Great Spirit in his native language. When he concluded the ceremony, I inquired about what he had been saying. He explained that if I had mistreated or disrespected the pipe or did anything unacceptable out of ignorance, he asked the Creator to punish himself, not me. I was amazed by this and learned something important about leadership that day. A true chief exists to serve his people and also stands first in line to take retribution and punishment.

Not long after Chief Heath consecrated the ceremonial pipe,

Medicine Grizzly Bear found out I had a new pipe. His deep regret that I'd lost my first pipe was replaced by joy. In ceremony, he made smoke with it for the first time and introduced it to the Sacred Directions, the Earth Mother, and Father Sky. He stared at the beautiful beadwork on the stem, and his eyes widened, "That is your signet! I've seen it in dreams!"

I had no idea what that meant.

"Each person has a design that's unique only to him or her. The color combinations in the beadwork are the ones I've seen that represent you. This pipe was meant for you ... before it was ever made."

Smoking Pipes—A Historical Perspective

Tobacco has always been a sacred element to Indigenous Peoples of the Western Hemisphere. The leaves from a number of plants that grow here are an integral part of ceremonies and have been smoked for hundreds of generations. Columbus wrote of seeing los Indios sucking on smoldering rolls of leaves and of being alarmed by the smoke issuing from their mouths and noses. This proved a pleasant experience for the White Men, and tobacco was one of the first products imported from the New World to the European continent.

There is some dispute whether smoking occurred in Europe before it was brought from the Americas. Pipes of iron, bronze, and clay have been found in Roman ruins, leading authorities to believe such pipes were used in ancient days for burning incense or smoking herbs or hemp. Throughout Great Britain and Ireland, small clay pipes are occasionally dug up. They are called elfin, fairy, or Celtic pipes. Nevertheless, tobacco was strictly a Western Hemisphere plant and its use by the Europeans brought smoking to a new level of use—and misuse.

How the first smoking pipes in the Americas came to be has long been lost in the clouds of history. Some historians maintain the Iroquois Nation in present-day northeastern North America smoked with the Vikings when they explored this continent hundreds of years before Columbus.

We can easily understand why inhaling the smoke from the burning tobacco leaf was so enjoyable that people devised tools to improve and enhance the effects. Archaeologists excavating pre-Columbian burial sites found pipe bowls a foot in height and weighing a dozen pounds. These bowls were hewn from stone or

wood and took many unusual forms, both animal and human. Stone pipes found in the Hopewell Mounds of Ohio represented birds, squirrels, dogs and other animals. The early tubular pipes of the Southeastern Indians were decorated with figures of ducks, wolves, and hawks. Out of the tubular pipes evolved many different shapes and forms. The Micmac Indians of eastern Canada used pipes with smaller, round-shaped decorated bowls. This style spread across the North American continent.

Pipe bowl materials varied from tribe to tribe. Indians fashioned them with whatever was available—bone, sandstone, soapstone, slate, bauxite, quartzite, stalagmites, wood, clay, and pipestone. But in one respect, all were the same: sacramental and believed to be of divine inspiration. The bowl was the altar. In it was burned the sacred offering: Tobacco.

Always on the lookout for pipe materials, in the 1600s the Sioux Indians of the northern plains made a tremendous find in the area that would someday be called southwestern Minnesota. They discovered quarries of pipestone (the scientific term is catlinite), a rose-colored stone ideally suited for pipe manufacturing. This stone was soft enough to be carved, but hard enough to be durable. The Sioux believed the pink stone was formed from the flesh and blood of their ancestors. Some American Indians traveled as much as a thousand miles on foot or horseback to obtain this unique stone. In the 1930s a major attempt was begun by the Pipestone National Park Association to have the United States Department of the Interior designate the area a National Park. They were eventually successful, and today the quarries are protected as part of the Pipestone National Monument, and their use is reserved for Native Americans.

The pipe stems were usually separate, although my first pipe had a stubby stem about an inch long carved in the base of the stone bowl. The stems were as highly prized as the bowls themselves because of their intricate designs and colorful decorations. Most were made of wood, such as ash. The wood was split, grooved, and glued back together to form a tube. Stems of sumac with their cores burned out were widely used, as were hollow reeds. The pipe stems had as many forms as the bowls. Some were flat, some rounded, some even corkscrew shaped. Some were decorated with feathers or quills. Others were bound with dog hair, horsehair, or buffalo fur. Still others were beaded, painted, or ornamented with tribal designs. Some of the stems were as long as three feet, and many were wrapped in bundles

of buckskin or carried in elaborately decorated pipe bags.

As smoking spread across the two Western continents, the character and appearance of pipe bowls and stems changed. Unique names emerged for different kinds of pipes. The most common were simply called plains pipes, but others were known as peace pipes, four winds pipes, micmac pipes, elbow pipes, claw pipes, and buffalo pipes. Pipes were often used to discuss war or peace, purchase a bride or horse, or settle a hunting land dispute. In the late 1700s the British and French began manufacturing trade hatchet pipes with bowls made of metal and formed into a hatchet shape.

A group of historically famous pipes were the Sioux calumets. Called the grand pipes, these specimens had long (two or three feet) wooden stems of ash decorated with feathers, beadwork, and painted symbols of a specific clan. The pipestone bowls were polished smooth and carved in the form of buffalo, bears, or an eagle claw. Decorations on the pipes were significant. The color of the feathers meant war or peace. These pipes were brought forth and smoked only on important occasions. They were used to mediate quarrels, set the stage for negotiations, and solemnize treaties. Violating a treaty sealed with the smoking of the calumet was to invite catastrophic misfortune. The presentation of the calumet implied the presence of the spirits. This understanding transcended all tribal lines. Carrying it ensured safety for the bearer and his or her party. The pipe was evidence of peaceful intent, a kind of universally honored passport. This was one of the reasons Native Americans were so devastated when the Euro-Americans participated in sacred rituals, then later disgraced and dishonored them.

The technique of smoking spread from tribe to tribe. Each group developed its own style of pipes and cultivated its own tobacco. Planting, growing, and harvesting became ceremonial events. Many tribes had two supplies of tobacco: one for sacred rites and the other for trading and for daily use. They learned to blend different kinds of tobacco and mix them with other aromatic leaves, such as sumac, and with the inner bark of the dogwood, or red willow bark. This mixture was called *kin-nik-in-nick* by the Indians of the Ohio Valley, and the term and process spread across North America.

Tobacco for medicinal purposes was carefully cultivated, nurtured and protected. It was harvested with time-honored ceremonies and stored in sacred places until it dried and could be crumbled.

The Indian ceremonial pipe and the sacred element of tobacco

played a significant role in the Natives' political life, inter-tribal parlays, and treaty negotiations. Today, it remains at the heart of the spiritual life of traditional believers, still linked with medicine and healing. Medicine Men still use the pipe in ceremonies to heal sickness and ward-off danger and trouble. The pipe is an important earthly element for making prayer invocations and initiating sacred dances and rituals.

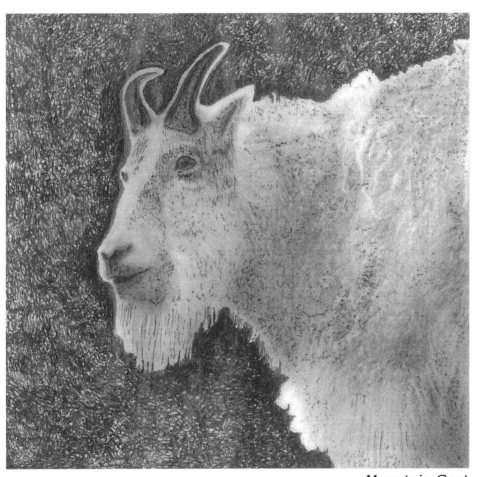

Mountain Goat

Mother Deer
Tah'-cha

Quietly resting through the night,
Deep brown eyes flame with Holy Light.
A gentle mother filled with care
For her two sweet fawns lying there.

Soft and gray her angel-like hair
Forms a new baby's cradle there.
"Sleep well, my babes" … with words not said
"Mother is here, be not afraid."

God knows what tomorrow holds
Joy or dangers yet untold.
Mother's love will always be near.
So live and grow and know no fear

Ha-Gue-A-Dees-Sas
2007

Chapter 7
Totems and Sacred Animals

Black Hills Medicine Power

Winters in the Black Hills of South Dakota bring bone-chilling cold and a lingering sense of melancholy because of the heavy snows and long bitter nights. During this time of year, my step-family's alpha males eagerly prepare for huntin' season. The younger brothers and cousins dread another week of freezing and degradation at Deer Camp. Pre-pubescent males only participate in this time-honored ritual to be subservient: "Shovel pathways, do the dishes, start the fire in the stove and keep it going, cut more firewood, and wait for your next orders."

The most dreaded duty is being one of the drivers. The dads and older cousins drop the kids off in snow up to their waists (if the temperature is above zero, they consider themselves lucky) and instruct them to start walking in a particular direction. The elders drive through the snow a handful of miles in the family Jeep, then sit on a fallen tree or in a thicket, pass around a bottle of whiskey, and wait for deer that are trying to avoid the drivers to stumble upon their stakeout. Amazingly, over the years, not one of the young boys has ever been mistaken for a deer.

After my first experience with Deer Camp as a scrawny thirteen-year old, I knew this was no place for me. I certainly had no idea I would experience a mystical and life-changing event.

On the next hunt, my step-father, little brother, and I were two days late for the reunion, so when we finally plowed our way to the cabin early that evening through a foot of recently fallen snow, the rest of the family males had enjoyed a head start in the hunting business. The headlights of the old Ford sedan illuminated a long, narrow tree trunk resting in the crook of two pine trees near the cabin's front door. Hanging from the pole, bent from the weight, were a half-dozen white tailed deer—heads down, their abdominal cavities propped open with smaller branches. They were frozen

hard as stones. A couple of the bucks were so large their horns disappeared in the snow beneath. Turning away, I felt a deep sense of sorrow. Tears welled-up in my eyes. I shook off the mood, knowing this wasn't an acceptable reaction if I wanted to fit in with the family

The next morning did nothing to improve my feelings of alienation and discomfort. It was a crystal clear day, bitterly cold, with not even a trace of a breeze. The rising sun struggled to reach its rightful place in the heavens. Strangely, the sun gave no warmth.

After a short drive from the cabin, we were unceremoniously thrown out of the Jeep and told to walk with the sun on our right ear. I wondered, "How far?" "How fast?" and most importantly, "Why?" One of the more experienced cousins noticed my puzzled look and explained our responsibilities: "Just keep quiet—and keep walking. "

He trudged off in the snow with the others in the direction of the disappearing Jeep, leaving me to my own thoughts.

I stood for the longest time, wondering what was going on and why I was a part of it. Then I noticed the silence. For the first time in my young life, I was immersed in complete silence. After a brief sense of panic, I felt relaxed and peaceful—unusual feelings for someone fighting the hormonal wars of that life stage.

After slogging through the knee-deep whiteness for awhile, I stopped to rest in a small grove of aspen on a gentle slope leading down to an open glen. I lowered my body into the snow and experienced the most pleasant, warm feeling. Someone told me later the early stages of hypothermia include a sense of comfort, despite the cold temperatures. A strange clarity washed through me, and I realized I could never kill a deer. It was wrong for me to be involved in any such activity.

I heard a voice say gently, "You're a good boy. What are you doing here?"

This snapped me back to reality and I looked around to see who was with me.

No one.

That day I knew the deer were special to me, but I didn't know why.

After that experience, I finished up the week volunteering to cut wood and sweep the cabin so I wouldn't have to go out with the hunters. One of the older cousins commented that I would make someone a good wife someday.

◊◊◊◊

A couple of years later I was once again out by myself at hunting camp—this time armed with a rifle I didn't intend to use. I heard the muffled sounds of large animals laboring through the deep snow in the thick, silent forest around me. Despite the painfully cold temperature, the rich, musky aroma of deer told me they were near. If you've ever experienced this fragrance, you'll never forget it. As I worked my way out of the thicket, a group of whitetailed doe bounded into the clearing, trying to jump as much of the heavy snow as they could. They would hesitate, then spring onward, moving toward me from the rocky ridge behind us.

"If you see doe," my stepfather once instructed, "be still and be patient. A big buck isn't far behind."

I held my .222 rifle in the crook of my left arm, peering behind the females for the elusive "big buck." I'd heard of people being trampled by the sharp, rock-hard hooves of deer. My mouth went dry, and I couldn't move. What chance did a scrawny young kid like me have if they went for me? In moments they were all around me. Then they stopped. Their beautiful black-brown eyes glistened like jewels. I smelled that unforgettable deer fragrance and heard their labored breathing."

Close to a dozen doe approached steadily and with determination. I wasn't sure they'd seen me. I felt a tingle of fear crawl up the back of my neck as they came uncomfortably close.

Some looked at me without fear and only passing interest. Two of the smaller females moved closer. I instinctively reached out to ward one of them off. She pressed against my hand. What now? She turned her neck toward me and I began to stroke it before I realized just how unusual this was. *I felt* the roughness of her hair through my glove. For some reason I'd always assumed a deer coat was soft and silky.

A moment later, the small herd continued through the snow drifts, moving away from me. I began to tremble, feeling the fear subside and relief flow through me. The deer aroma lingered in the air and on my glove as I tried to recount what happened. Was it a dream? I looked around. Plenty of ciphers in the snow verified they had been there.

I never hunted after that.

◊◊◊◊

Years later when I told this story to the Medicine Man, he exclaimed, "They chose you! You received your animal spirit guide as a young man and didn't even know it. Now that you're walking the pathway toward Native American spirituality, you're being prepared to acknowledge its presence in your life. Remember what I have taught you: a totem is an animal that has adopted you and will always be there to protect and guide you. "It's rare for a man to have a deer as a totem. Usually deer are women's totems. You've got power!"

Finding Your Totem

The initial steps for finding your totem are the same as other spiritual pursuits: You must first believe in the phenomena of totems and know your personal spirit animal wants to be identified.

Secondly, as a novitiate, you must open your heart and mind to the call of your totem. Traditional Native Americans believe without equivocation that everyone has an animal spirit walking through life with them. A person may not be aware of this or even care, but that doesn't alter the facts. Each totem is trying to touch its human— offering a sense of peace and the realization that we are never alone.

Spirit animals use creative avenues while trying to embrace their people. They can communicate through actual animals, manifested by a penchant or warm feeling toward a particular animal species. If you love dogs, your totem may be a wolf or coyote. If dogs seem to take to you in a comfortable and natural way, this reinforces the idea. Cat lovers are special people. Cats don't warm to just anyone and seem to sense who should be avoided. If you like cats and find them rubbing against your leg or climbing into your lap without invitation, placing their heads by your hands or face or licking your face with their rough tongues, a totem from the cat family may be working through the cat to touch you.

If you live on an island, along the ocean, or on the banks of a large lake or river, you may have a fish, whale, or dolphin waiting to be your totem. Keeping an aquarium in your home and wearing jewelry or accessories with a fish theme is another sign. Some people even have a fish tattoo, but can't explain why they selected it. People who enjoy swimming, diving, and other water-related sports are more inclined to hear the secret calls of our finned relations.

You may find yourself sketching or painting bird pictures or hanging bird themed art work on your walls. If you enjoying bird

watching, and keeping bird feeders and bird baths in your back yard, a Spirit Bird may be singing to you.

After my experience that cold winter day in the Black Hills of South Dakota, I've always felt a special love for the Deer People. Venison was one of the few meats on our table during my growing up years, but I couldn't eat it. I didn't especially care for buffalo, but could swallow it with plenty of catsup or mustard. Every autumn my mother served antelope, which I could tolerate. But I couldn't even stand the smell of cooked deer meat. My family used to kid me, saying I was becoming a vegetarian. When I stared at venison on my plate, I felt I would almost be a cannibal if took a bite.

Your personal dietary preference may indicate what your totem might be. If you belong to a particular family of animals, you won't like eating one of your own relations.

I enjoy the deer fragrance and feel a sense of love and admiration when I see these magnificent creatures in the wild. I can whistle to a deer trotting across a field, and it will stop and look at me. I send a friendly message in my mind and wish it good fortune.

An elderly Catholic sister once gave me a wrist rattle made of deer hooves. She didn't know why, but knew it was for me, even though she'd carried it for many years and received it as a gift from Native Mexicans she'd done missionary work with long, long ago. Once your totem has been determined, you'll be amazed at the ways you relate to each other. This bond will grow stronger through the years.

Spirit animals try to reach you during times when you aren't distracted by trials and tribulations of daily activities. As you begin seeking your totem, you may experience dreams or visions of wild animals. When you awaken, try to remember the dream or vision and record it in a journal. Look for a common theme or repeated pattern. Some say you have a better chance of remembering a dream if you tell yourself before you go to sleep to do so.

Your totem may also try to touch you when you're in an altered state from such things as a serious injury, critical illness, a life-changing accident involving excruciating pain, extreme anxiety or fear; or involvement in a near-death experience. In a less traumatic way, your totem might try to contact you while you're passed out or knocked out from a chemical imbalance, drug or alcohol overuse, or involvement with peyote or some other hallucinogenic drug. As a person returns to consciousness, he or she may not remember the

intervention, but the communication line has been connected and will become stronger.

The third step in finding your totem may be the most difficult, because it requires action on your part: Be willing to walk the walk to totem realization. The totem-human bond is a two way street. The animal spirit reaches for his special child, but that person must also stretch out a hand. Like so many Native American spiritual quests, the seeker needs to prepare:

- Get into a receptive frame of mind—expect something wonderful to happen
- Cleanse yourself from the effects of drugs and alcohol through abstinence and drinking distilled water. Let your body flush impurities down the drain. Consider a water-only fast for three days.
- If you can access a sauna or sweat lodge, this will hasten the cleansing process as your body perspires out the toxins. If you have Traditional Native American friends, ask that person to smudge you with smoke from cedar and sagebrush at least three times in succession.
- Seek internal peace through meditation or prayer. Plead to the Great Spirit (whatever you may call him) to be forgiven for your sins and iniquities and the actions and in-actions you have committed that hurt people during your life. (This is called peh-ga-soy in the language of the Yurok Tribe of northwestern California).
- As you fast and prepare, find a place to isolate yourself from the hubbub and turmoil of daily life. Some Native practitioners say a woman should not pursue this activity if she is on her moon time.
- Most difficult of all, clear all the tapes and constant chatter flowing through your mind, so you may quietly and intently listen until you can hear that still small voice saying, "Come home."

Refer to Chapter 14 for more information and ways to begin seeking your spirit animal.

Sacred Animals

This topic is frustrating for me as I continue down the pathway of Native American spirituality. We've learned that traditional Native

Americans see all Nature as sacred. The Four-leggeds, the Flyers, and the Swimmers are our relations. Even inanimate parts of the environment are called people, such as rock people, tree people, and cloud people. To complicate matters, different First Nations, tribes, villages, and even individuals view their environment from a unique perspective.

An example of this occurred when I talked to my Indian friends about the night of my vision quest at the Medicine Wheel in Wyoming when my friend Adam and I were attacked by Great Horned Owls. Some Native Americans are uncomfortable around owls, because they feel owls bring bad news and portend death. They say owls have an evil function and role as messengers and challengers. "I heard the owl call my name," is a common statement by Natives who feel they may soon be joining the spirit world. I shared the experience with a lady friend who was a member of the Caddo tribe in American's southeast. She smiled and commented that owls bring great news and good luck. She assured me we were blessed by the experience. Another acquaintance, this one from the Assiniboin Nation of eastern Montana and western North Dakota, stated flatly that owls are messengers and are neither good nor bad. They bring whatever news the Great Spirit instructs them to communicate. A Native friend of mine who is a professional educator was quick to tell me the owl incident had no special meaning at all. This was normal nocturnal hunting procedures, and we happened to settle in their flight path.

Just when things couldn't get more complicated, my special lady friend from the Yakama Nation of central Washington State asked how I even knew the owl was corporal. Perhaps it was a Spirit coming to me to bring me the vision I'd been seeking—and we threw rocks at it!

Across the First Nations, many people believe animals are messengers. The kind of creature carrying the message is determined by the natural environment in which the people live. Northwest coast tribes watch for seals and sea lions—confident they will alert the people of impending disaster. Orcas are especially important, and local Medicine People may row their canoes into a pod of whales to enhance communication. The whale is especially sacred and they address this magnificent beast as "Grandfather."

The alligator is feared and respected by the Swamp tribes of the Okefenokee and Everglades of the American southeast. For

generations beyond count the Natives offered sacrifices and prayers to these creatures, invoking their powers and their survival abilities. Far above the Arctic Circle, nomadic Eskimos worshiped the polar bear and made amulets in their likeness for protection and good health. Bears, wolves, elk, moose, and other impressive mammals fill the stories and traditions of Native tribes. Coyote walks in and out of the creation stories—usually as a rascal, thief, or teacher.

The lowly gopher or ground squirrel is a perfect example of how different tribal groups classify sacred animals. Despised by farmers and ranchers, he is hunted mercilessly, blown up, or flooded out. A common explanation for the carnage is that horses and cattle would step in the gopher holes and break their legs. I was raised in ranch country on Yakama Indian Nation land in central Washington State and never heard of such an event. The Shoshone Indians of the American West believe the gopher is a doctor and can help take away sickness if the ill person goes to his hole, makes an offering, and asks for help. If the gopher crawls out of his den and digs around, it means he's taking away your sickness, pain, or disease. Other tribes, especially in northwestern California, believe the gopher is a messenger of death. A gopher digging a hole in a yard near a house means someone known by the family will die soon. The little critter's actions represent digging a grave. The closer the gopher digs to the front door of the house, the closer the dying person is to the members of that family's circle. Should you see a gopher digging a hole in your garden, don't be alarmed. It simply means he's hungry. If gophers are pests, offer them food and ask them to move on.

Deer are universally seen as good by Native inhabitants of the forested and grassy plains regions. As we establish a totem-human relationship with deer, they become our eyes and ears. They provide travel mercies, can assist us in foretelling the future through dreams and meditation, and remind us to experience lives of balance and grace.

Eagles and Ravens are sacred to almost every Native culture. Their feathers, wings, heads, and claws are power objects used in ceremonies and rituals. Generally, the eagle represents strength and the raven wisdom. The Tlinget Nation of southwestern Alaska has divided all Two-leggeds into two clans: Eagles and Ravens. Some believe the Raven is the only creature that can travel from this world to the afterworld and back whenever he feels like it, or when the Creator calls him.

My friend and spiritual advisor, Medicine Grizzly Bear, was preparing to return to the Lower 48 States after some months in Alaska doing healings and ceremonies and helping Native corporations gain government grants. He shipped multiple boxes of his regalia to my home so we could store it until he got situated. My ex-wife's cat got into one of his boxes, found a precious eagle claw, and chewed on the claw until it was reduced to gristle and toe nails. I was furious and would have gladly strangled the animal if I could have caught him. Grizzly Bear, with admirable grace and humor, laughed and told me the cat was now a power object and I should be more respectful. He also said we both had to do a smudging ceremony, say our peh-ga-soy (apology) clean up the power object as much as possible, and apologize to the Eagle spirit.

Consider the lowly Turtle. Again, the First Nations look at this strange creature in different ways. Usually, turtles are considered good signs and good power. The Sioux of America's north central plains say a turtle stands for strength, resolution, and long life. In their mythology, a turtle heart beats for days after the turtle itself is dead. It communicates with thunder and can bring rain. In traditional Sioux families, a beaded medicine bag or talisman in the shape of a turtle is attached to a newborn's crib. The baby's umbilical cord is placed inside the charm to protect the infant from danger and evil spirits. Turtle soup is not an uncommon part of their weekly fare and Sioux elders prefer it to commodities offered by the U.S. Government. However, northwestern California Natives believe they should never eat turtle. To do so will bring bad luck and sickness.

Even the smallest insect can be considered sacred by some Native groups. The tiny carpenter ant represents the ability to travel and establish new homes in strange places. It is also a symbol of strength, intelligence, clear thinking, and planning ahead. It's considered a pest by many people, but some tribes would never harm a carpenter ant if it lands in their area, and may even present it with some form of food offering. Tradition says the carpenter ant especially likes pemmican (a traditional Native treat made of animal tallow and berries) and will repay the people with a special blessing.

As you move further into the realm of American Indian and Alaskan Native culture, study the clothing and regalia of traditional tribal members and the outfits of dancers and powwow attendees. You will see a kaleidoscope of animal contributions to their attire, including bear claws and teeth, porcupine quills, feathers from

many birds—natural or dyed—bones and skulls, and actual pelts, often with heads still attached. These elements symbolize a sacred relationship between the dancer and a spirit animal. Dancers perform not only for personal enjoyment and spirituality, but to honor the totem and the spirit animals identified by their First Nation, tribe or village.

Each dancer's movements tell other competitors of his power allies and protectors. This can be a way of saying "Back off!" if others harbor ill feelings. As a powwow observer, you'll see what each tribe considers sacred and worthy of special honor.

Gate at Wounded Knee Cemetery

Death
We-cha'-tah-pe

Death affirming … or Death denying.
If you're for sale, then I'm not buying.
Your indiscriminately reaping
The young or old … awake or sleeping.

An endless walk. When will you tire?

You stride the dry Earth in baleful glee
Ever seeking out both them and me.
"Hey! Don't knock on my door. I'm not home.
Hold back your hand and leave me alone!

Nobody build my funeral pyre."

Ha-Gue-A-Dees-Sas
2007

Chapter 8
Death — A Part of the Circle of Life

The Littlest Angel

Christopher did not look good.

He was pale and slim, with dark rings under his dull eyes. When I gently touched his shoulder, he lacked the familiar "snap of life" so noticeable in other children his age. This was 'Topher's first year at school, the most exciting time in a child's life, yet he moved like an old man and every motion seemed painful. 'Topher was dying of leukemia. This sweet little person had already placed his footsteps onto the pathway of diminishment, and he was barely five years old. Death's dark mask maliciously peered into the hallways of our elementary school. This felt especially grievous because schools are so filled with life.

His classmates reached out to him with fondness and affection, though they didn't know nor understand what 'Topher was going through. His mother told me the most important thing in his life was getting to school … one more day.

Months before his real birth date, 'Topher's mom and dad held a special birthday party for him on a Friday. All his classmates and their parents were invited—and everyone attended. He was heavily medicated to combat the unyielding pain, but his eyes had come alive. How incongruous this vision: Bright eyes—a dwindled body, colorful party hats, a pale and colorless face, happy music—and the weight of reality.

'Topher wasn't in his seat Monday morning. A ray of sunshine from the window illuminated his empty chair.

As school principal, it was my task to tell the children their friend had died over the weekend. With deep trepidation, I entered the classroom and watched the students quietly cutting and pasting at their tables. They seemed to know innately what had happened, though no one told them.

'Topher's empty chair said it all.

Calmly, with childlike reverence, they were talking about him. . .

In trust and acceptance, they comforted one another, saying their classmate was in heaven with Jesus and not in pain anymore, and everything was okay. With wondrous wisdom they accepted death as a normal part of life, and after that acceptance they moved on with the day.

Through teary eyes, the teacher and I shared a brief glance. She smiled and nodded.

I, too, moved on into my day.

A room full of five year-olds taught me a lesson I've never forgotten.

Death Affirming—Death Denying

American Indians and Alaskan Natives deal with death in diverse ways, based upon their cultural beliefs. Even within each society, the sub-cultures, families, and individual members may have different customs. They share one fundamental belief: Death is a normal part of life—and our lives are a circle, not a linear timeline that ends when we die.

In general, societies view death in one of two ways:

- death-affirming
- death-denying

A death-denying society tries to hide from old age, illness, and grieving. They strive to prolong life beyond what seems reasonable, even when the body has given up. Children learn three things: don't talk about death or acknowledge grief; be strong and put on a smile no matter what; and move on as fast as possible when someone dies. Woody Allen summed it up for most Americans when he said, "I am not afraid of death. I just don't want to be there when it happens."

I recently heard an example of death-denying from a nurse friend who worked in the geriatric wing of the local hospital. Over the years, she helped many patients pass from this world to the next. One elderly man was especially memorable because of his inability to accept the inevitable. Apparently, his entire life revolved around being in control of every situation. He wasn't a loving man, and the nurse wondered if he'd ever been loved. He ruled his environment with an iron hand. His final days in the hospital were filled with anger and a deep sense of injustice, which he vented on the staff and the occasional visitor. The gentle nurse stood by him that fateful night as he thrashed and kicked, cursed and screamed while death

closed around him. As his spirit left the body, his fists were still clenched and the ghastly death mask on his face reflected the anger and pain of his last moments, still denying the Grim Reaper.

Traditional American Indian and Alaskan Native cultures are death-affirming societies, and their views on this subject can help all of us. The sacred circle of life, so important to Traditional Natives, has no beginning or end. This sense of the cyclical provides comfort, because we realize death is not the end of everything, but only another step around the great circle.

Death Rites and Rituals

Each tribe has specific beliefs and practices surrounding death. Some years ago, I lost a good friend who was living with the Quileute Nation on the Olympic Peninsula of Washington State. He was one of the tribe's sea-going canoe carvers, held in high esteem by the people. I traveled to their village to pay my respects and visit with his widow and children. I wasn't sure of his address and couldn't find it in the local phone book, so I headed for the community center to ask directions. A meal for the elders was in progress, and as I approached a graying gentleman, I had a rude awakening. The elder wouldn't answer my inquiry and kept talking about my deceased friend's brother, Charles, whom I also knew. This was frustrating for me, so I tried to explain I wasn't interested in my friend's brother. After repeated efforts to get information, I left in a huff. Later, I found out that when a Quileute dies, no one can speak his name for a year. The elder was trying to tell me I should ask about the whereabouts of Charles' brother's family. I should've done my homework before making the trip.

According to tradition in the Arctic Nations, an ailing elder preparing to die will go away from the village, finds an isolated spot where polar bears are known to congregate, then sit on the ice to freeze to death, and wait to be eaten. The elder's body will nourish a bear, which may be killed by a younger member of the tribe and will then nourish the descendants. My middle daughter, in a form of gallows humor, asked me the other day if I was ready to sit on an ice floe. I reminded her of another Eskimo tribal custom: When a child visits her parents, she brings lavish gifts or money.

After the Christian church entered the lives of Indigenous people, many tribes began conducting funeral services in a church or mission. But, even today, many tribes still hold a wake for the deceased that

includes traditional ceremonies. A tribe or First Nation may prepare a feast in honor of the dead person or family, and the entire village may be required to fast in mourning. The burial ceremony might consist of a celebration with fond memories and laughter, or it could be a somber, heavy response with wailing and self-laceration. Survivors might wear black, or the color for death may be white. Some Indian groups perform dances of the dead with spectacular masks and regalia, while others respond with a period of silence and no celebrating at all.

The mound builders of the eastern plains of the United States buried their dead with paraphernalia for a journey to the afterworld. Many Eastern Woodland tribes placed bodies in reed blankets before burial, while others removed them to sacred high places, or deep in the forest. Some cremated the remains with great ceremony, while others built a platform in the wild country and placed the body face-up, along with his or her belongings, for the forces of nature to claim. Inland tribes had burial grounds where the deceased were put back in the earth—and many of these were disturbed over the years in the name of science. Native people who lived along the coast and beside large rivers put the bodies in canoes and let the water take them away.

Always respectful and gentle toward their own dead, most Native groups had no tender feelings toward dead enemies. They defiled the bodies by scalping or decapitating them and sticking the heads on spears. Some even cannibalized the enemies, or cut out their hearts and ate them to gain power.

American Indian and Alaskan Natives understand death is part of life. Elders were known to say, "It's a good day to die." And then they would. This lack of fear about death make Indian warriors fierce fighters and exemplary soldiers, even today. The downside of this belief is a casual, careless attitude toward life, leading to self-destructive behavior such as alcohol and drug abuse, reckless driving, taking unnecessary chances, and suicide attempts—all too prevalent both on and off the reservation.

◊◊◊◊

Buffalo

The Old Warrior
Kon Zoo-yah' We-chosh'-tah

My bite was of an angry wolf.
My teeth were white and strong.
My feathers were like river rocks,
Each one my right hand won.

My enemies fell on their knees
And cried in their defeat.
They broke their bows and tomahawks
And placed them at my feet.

Now I watch our brave young men
Riding off to war.
The maidens chant their farewell songs
Of long remembered lore.

My knees are stiff, my teeth are gone,
My eyes no longer keen.
No one seems to know my face,
So seldom is it seen

Mighty, mighty, great in war so was I honored,
Now, behold me: old and wretched.

Ha-Gue-A-Dees-Sas
2007

Chapter 9
Song of the Warrior

What is a Warrior?

Warriors come in both genders: male and female. A warrior may be a fearless man holding a weapon on the battlefield, a young woman hustling up and down the basketball court, or a single mother working two jobs for her family.

The most important attribute for a Warrior is a sense of caring for and protecting others. This passion sustains the Warrior against all challenges.

A Warrior's worth is validated by tribal tradition, the actions of the people, and the expectations and understanding of those around him or her. Tribal leadership acknowledges the Warrior with appreciation and respect.

A Warrior seeks guidance and listens to the Elders, tribal leaders, and Medicine People. He or she is in constant training for physical, mental, and spiritual self-improvement.

A Warrior knows which battles to fight, based on tradition, the experiences of older Warriors, and the needs of the village or society.

A Warrior has a good heart and a kind spirit. He or she can draw upon inner power for the strength to bring honor and peace to those under his care.

A Warrior protects her people.

My Warrior Walk

My friend and spiritual advisor, Medicine Grizzly Bear, had been looking at me as if deep in thought. Usually, when he did this he was talking with my Spirit Guide—whom he described as an elderly, but spritely, American Indian man. Another culture might call this entity a guardian angel.

At last, Medicine Grizzle Bear's body language told me he'd made a decision. He pulled himself out of the easy chair, "I'll be right back. It's time to give you something."

He returned a few moments later with a beautiful medicine bag about 5-inches by 4-inches in dimension. The bag was beaded in red, white, and blue with the peyote design of interconnected triangles. The leather necklace was also beaded and had dentalia shells among the colorful bits of glass and plastic. This was an exquisite article of American Indian craftsmanship. In the bartering days of Native Americans, dentalia shells were considered wampum (Indian money).

"You're going to need this to keep your stuff in. You're about to begin your Warrior Walk."

My blank stare told him I had no idea what he was talking about, so he patiently explained, "Adolescent Native boys are directed onto the pathway of becoming adults and Warriors. As they're trained and educated, they participate in ancient rites and ceremonies. During this time they receive amulets or talismans as indicators of their progress. These talismans are like benchmarks and they can be anything. At first the relationship between each of them is a mystery, but later everything becomes clear. Receiving the fourth of these talismans is the sign they met the requirements and they're prepared for the naming ceremony. You have your Indian name already, Ha-Gue-A-Dees-Sas (Man Seeking His People in Seneca language), but you can't really claim it until you finish your own Warrior Walk."

He continued, "In some Traditional Native cultures, men and women are given three names during their lifetimes. The first name comes at birth and is generally a gift from the father or an older relative, maybe a grandfather or uncle. In many cases the name comes from something unusual that happens in nature during or after the child's birth. This is how my daughter, Moon Raven, got her name. I'd been fasting and seeking a vision in the sweat lodge, asking the Great Creator and spirits what I should name my daughter. I had a vision of a large Raven standing in the middle of a full moon—so I named her that. If I had any doubt about what the spirits showed, the name was confirmed when we left the sweat lodge and bathed in the nearby pond. I'd just told everyone inside the lodge about the vision. After we came out, I heard a Raven call. We turned around and saw it sitting on the lodge with the full moon behind it.

"In some Tribes, Traditional Native children get their second name when they complete the rites of passage to adulthood, either the Warrior Walk for boys or the Moon-Time ceremony for girls. Later in life, they receive the third name when becoming an elder.

This name is usually related to something they've accomplished in their lives, or their role in the village."

Medicine Grizzly Bear put his hand on my shoulder, chuckled softly, and looked into my eyes. "You, my friend, are about forty years late for your Warrior Walk, so this isn't going to be easy; but then it never is. That's what makes it something of value."

I found myself thinking about what a name stands for and how it comes about; how deeply important a name is. The Holy Bible repeatedly emphasizes names:

> *"And out of the ground the LORD God formed every beast of the field, and every fowl of the air; and brought them unto Adam to see what he would call them; and whatsoever Adam called every living creature, that was the name thereof. And Adam gave names to all cattle, and to the fowl of the air, and to every beast in the field..."*
>
> Genesis 2:19-20

When Father Abraham and his wife Sarah wandered into the Promised Land from the wilderness they were called Abram and Sarai. When God chose them, He gave them new names. When Jesus, son of Joseph, was eventually recognized as the True Son of God, he was addressed as The Great I Am. St Paul was known as Saul of Tarsus the Christian Killer before his transfiguration to defender of Christ's message.

Across this continent, tribes named themselves The People or The Human Beings in whatever language they spoke. All other Two-leggeds were referred to as The Others, or a different label implying lower status. The Others were often labeled as animal-like or lessened in the image of the Creator.

I worked for years with an Alaskan Native woman who married an American soldier from Fort Richardson, then traveled the ends of the Earth while he was deployed in Europe and Asia. She told me her people named her Doe Eyes as a child. After the wedding ceremony she was taken to the Moon-Time lodge with a group of the village women and gifted with a new name that seemed touchingly appropriate: Woman Coming Home. This name gave her special peace, knowing that no matter how long it took or how far she traveled from her people, she would someday return. The tragedy of

this story is that she died of cancer before feeling the sacred grounds of her home once again.

After agreeing to take my Warrior Walk, I participated in sweat lodge ceremonies, tried to be honorable toward Earth Mother, visited high places, and made every effort to live a meaningful and helpful life. I endeavored to receive knowledge of traditional American Indian spirituality practices with an open mind and blend it with my own faith.

One day, an unusual item arrived for me: a single bear claw. This gift came from Medicine Grizzly Bear, who directed my training. A bit of hair and dried flesh still clung to the claw, as if it had been ripped from a bear's paw. He instructed me to put it in my medicine bag. As I did so, a stirring inside me told me this was my first talisman. When I opened the bag, I was surprised to find a small feather, a piece of Grizzly Bear Root (Angelica), and a sprinkle of herbs of some kind. I guess I'd thought the bag would be empty until I started putting things in it.

A year passed without other benchmarks to assure me I was still on the Warrior Walk. Then the second talisman arrived, quietly and without question—a small silver cross, about 2-inches by 1-inch. The cross reflected the afternoon sun, taking on an unusual golden glow. Again, I instantly knew this was my amulet. A bear claw and a Christian symbol. How were these two items related?

Not long afterward, the realities of life crashed down on me. The rift growing between my first wife and I had become a chasm. Our breakup was a tense, unpleasant experience that absorbed all my strength and energy. Years passed before my life returned to some degree of normal. During that time, my Warrior Walk came to a halt.

Not long ago, another surprise reassured me my Warrior Walk was resuming. In the mail came my third talisman—so completely unrelated to the other two that even the farthest reaches of my imagination couldn't connect the three items. I received a piece of meteorite about an inch across: a space rock. Once again, I knew it belonged inside my medicine bag.

When Chief Delvis Heath of the Warm Springs Tribe of Oregon and I met during my visit to the Kah-Nee-Tah Resort, I told him about my Warrior Walk and asked him what a naming ritual might consist of with his people. He told me he'd be happy to lead the ceremony once I received my fourth talisman, but I needed to know a few things ahead of time.

The sweat lodge experience was the first step, leading me to participate in a Vision Quest in the backcountry. Once I embarked on the Vision Quest, animals would find me and talk to me. They would tell me about myself and give me information I would need for my present life. They would have answers to the questions I lived with. However, if I told anyone what they said, the animals would never speak to me again. This indeed would happen. The thought of this was so intriguing, I felt impatient to know more about the experience.

"There is more," continued the Elder. "For every man who helped you spiritually, you must give him a full-size Pendleton blanket. For every woman who helped you, a bolt of fine cloth. Then you must take another roll of cloth and spread it on the ground. We call this The Highway. You must have enough gifts so everyone at the ceremony can take something home; like jack-knives or China cups and saucers, electronic gadgets, and so on. You know what I'm saying—a give-away."

Now I knew what to expect.

I wonder what my fourth talisman will be. I'm sure I'll know when it arrives. I still have many questions, but I know everything will indeed come together in the Fullness of Time.

A Prayer for All Warriors

While I served on the board of the American Indian Community Center in Spokane, Washington, I had the honor of visiting an old warrior (although we were about the same age) who was at Wounded Knee, South Dakota in 1973. During this crucial time, the American Indian Movement (AIM) and the U.S. Government went eye-to-eye over critical issues of self-determination and justice. The warrior was part of the occupation of the village during the 70-plus day siege. He faced the federal agencies on site, the Pine Ridge Reservation tribal police and governing body, and local people who opposed the goals of AIM.

He sadly shook his head and lamented how little appreciation those brave people who stood up against the establishment received for the price they paid. Even today, those warriors are considered radicals, even Communists, who set back the progress of interracial relations.

Filled with despair, he said the new generation of young people doesn't care, or even remember, what happened on the dry plains of

South Dakota that fateful spring. The siege at Wounded Knee led to increased support, respect, and sensitivity for Native Americans, but no one remembers the Warriors who were there.

I've thought about his litany many times. I wasn't there, fighting for the rights of American Indians, though I could have been. I was busy teaching school, raising my family, and pursuing the American dream. I'd been almost completely assimilated into the Dominant Culture and had little patience for the people who holed-up at Wounded Knee. In many ways, I was one of the new American Indians he referred to.

Much later, during a quiet moment of meditation, a strange thought walked into my mind: *Was this not the true repayment for a Warrior's effort — the most significant reward these brave people can hope to receive? Because of their sacrifice, the next generation can know peace and forget war.*

I find myself hoping the old Warrior will someday find peace in knowing he did his job, and did it well.

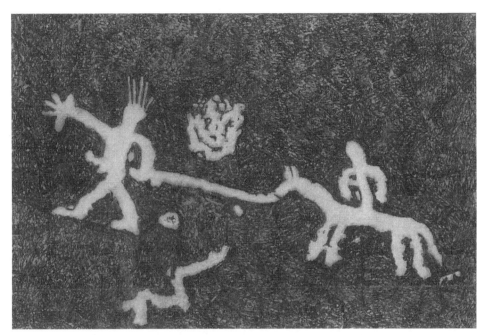

Petroglyph

Rock Writing
In'-yon Wah-oh'-wah-pe

Strange designs on canvas of stone
Who were you speaking to?
Are they tomes of your precious homes
Or were you passing through?

Earth Mother wants her child clean.
Its always been that way.
With wind and rain and heat and cold
She sweeps it every day.

And so the story of your life
Fades before our very eyes.
Once bright and clear against the rock
Today it barely sighs.

Is this God's use of metaphor?
A lesson to be learned?
Simply a trace that we were here
Now no one is concerned.

Ha-Gue-A-Dees-Sas
2007

Chapter 10
The Rock People

Finding Your Watai

For thousands of years I have spoken the language of the land and listened to its many voices.

<div align="right">

(Chief Dan George 1974)

</div>

The mountains skipped like rams, and the little hills like lambs.

<div align="right">

(Psalm 114:4)

</div>

The wilderness and the solitary place shall be glad for them; and the desert shall rejoice ...

<div align="right">

(Isaiah 35:1)

</div>

... and break forth into singing, O mountains ...

<div align="right">

(Isaiah 49:13)

</div>

When traditional American Indian and Alaskan Native Medicine People participate in spiritual ceremonies, they offer a prayer to the Rock People as well as to the Creator God, creatures of the earth, and the sacred directions. They see the Great Spirit's touch in all aspects of their environment and through all Creation. His handiwork is found not only with the Four-leggeds, Two-leggeds, Flyers, and Swimmers, but also with inanimate objects such as mountains, rainbows, rivers, stars, trees, and even stones

A traditional American Indian legend tells of the Watai—a special rock among billions scattered across the face of Mother Earth. The Watai contains a personal message for every person who ever lived—a stone silently brooding since the dawn of time, marked by the Great Spirit with medicine, power, wisdom, and truth for each person's life. This stone awaits those whose spiritual journey takes them from the distractions and trifles of the modern world—back to the earth and a humble rock.

My Watai came to me attached to a leather necklace comprised of old Hudson's Bay Red beads and silver trading beads. It is a four-inch long, clear quartz crystal given to me by an Indian Medicine Man in response to kindnesses offered him and to his family. The Medicine Man wove this tale of the stone:

Since ancient times, it grew in the womb of the earth. Eons later, a Lemurian Holy man respectfully harvested it and used it for healing and communication. (In some ancient legends, Lemuria is the West Coast equivalent of Atlantis and was located off the coast of present day California.) Even today, some Northern California Indians say the magical city of Lemuria exists under Mount Shasta where the people patiently await the emergence of a fresh and clean New World. The In'-yon (stone) was passed down through the ages, used in rites and ceremonies. The Spiritual Leaders did good with the crystal, and it was always a blessing to those who came in contact with it. This is the story the shaman attests the stone told him.

When he gifted the crystal to me, it was almost as clear as new glass. Close inspection disclosed a bit of rainbowing if I held it just right in the sunlight. Over the past 20 years something strange has happened to my Watai: Colorless wisps and feathery shapes, called inclusions, are growing within it. When I asked the Medicine Man what was happening, he said my crystal was taking on my illnesses and impurities. This would ensure I lived a long, healthy life.

Later, I showed the stone to a geologist friend who teaches at a nearby university and could appreciate the crystal from a scientific point of view. His explanation for the feathering is that all rocks, including quartz crystals, have cracks and fissures, some so small they can't be seen. Water vapor eventually works into these faults and discloses them. He suggested putting it in a container of rock salt, rough side down, for a period of time. The salt would draw out the water vapor and eventually cleanse the stone.

If we can accept the idea that somewhere The Great Watai given to human-kind by the Creator God is waiting to be discovered, and if we can accept the possibility that there may be a personal Watai for each of us; think how this changes our perception of the world around us. We will become more appreciative of our environment and less eager to dig, bulldoze, excavate, and pave-over everything. Imagine Creator God's exasperation with us if He knows The Great Watai is covered by ten feet of concrete in a bunker at the end of some airport runway, or is a part a breakwater off Galveston, Texas.

Even if it cried out to us, its cries were hidden by the roar of giant construction equipment. Perhaps that voice is forever muffled.

I hope your Watai is right by your front door or under a few inches of soil in your flower garden, waiting to feel your hand and hear your familiar voice. Oh, what stories are waiting to be told! I take comfort in having a personal Rock Friend who knows my name and was eager to become my companion. Robert O'Rourke, a Colorado writer and folk artist, found his Watai "…not on a sacred prairie, but in a noisy city parking lot. An orphan! So out of place there."

If you haven't found yours, then begin looking to the earth for a humble rock.

Discovering the Power and Spirit of Crystals

The Rock People come in countless varieties. Like people, they differ from one another in color, size, hardness, specific gravity, texture, translucency, and aroma. The crystal is an important rock family used for thousands of years in religious and spiritual practices. Crystals have been found in the tombs of priests and royalty in archaeological digs on every continent.

We can hardly comprehend how ancient a crystal may be. Tila Starhawk Donohue, a Yurok Indian Medicine Woman by inheritance and training, was given a quartz crystal about three inches long with a trilobite encased in the stone. The time it took for the crystal to grow around the creature must have been measured in eons. Tila felt the incursion was blocking the energy flow of the crystal, so she had it removed by laser and gave it to my father some years ago. I was totally dumbfounded. The rarity of such a find must be beyond measure.

Crystals, especially members of the quartz family, are referred to hundreds of times in the Holy Bible. Notice how many types of crystals were placed in the foundations of the New Jerusalem:

> *And the foundations of the wall of the city were garnished with all manner of precious stones. The first foundation was jasper; the second sapphire; the third, a chalcedony; the fourth, an emerald; the fifth, sardonyx; the sixth, sardius; the seventh, chrysolyte; the eighth, beryl; the ninth, a topaz; the tenth, a chrysoprasus; the eleventh, a jacinth; and the twelfth, an amethyst.*

Revelation 22: 19-20

An amethyst is mentioned as the ninth stone on the breastplate of Aaron, Moses' brother and an ancient Hebrew High Priest. It represented one of the 12 tribes: "And the third row a ligure, an agate and an amethyst." (Exodus 28:19).

In many ancient societies, the privilege of owning quartz crystals was restricted to priests or Medicine People. The Chinese and Japanese discovered caves of crystals and used those caves for training their religious leaders. They were heavily guarded places used only by the specially initiated. The Sioux nation honors an unusual volcanic mesa just east of the Black Hills of South Dakota, called Bear Butte. Crystal people tell me they can hear it humming as they drive by on Interstate 90. My daughter and I endeavored to climb the butte a few years ago. She was so overcome by the crystal hum that she had to stop climbing.

The idea of a crystal ball goes back farther than history can remember. These orbs of purest crystal have long been used as talismans, aiding contemplation and communication for spiritual purposes.

The Roman and Eastern Orthodox Catholic churches give each bishop an amethyst quartz crystal as a symbol of spiritual power. They also use gems and crystals in the Eucharist and in building the altar of the Seven Rays.

Modern day Native Healers and Medicine People use crystals for protection, good health, communication, meditation, and healing; and also as focus objects during rites and ceremonies. They say the crystal enhances mental energy in a dramatic way, amplifying body energy and our thoughts. They create power and clarity in thinking, enabling thoughts to more effectively influence matter.

As with all good things in nature, crystals can be used for evil purposes or weapons by sorcerers. Knowledgeable crystal people do not use their gems as forms of showy jewelry, earrings, or necklaces. They may wear a crystal necklace under a shirt or blouse for protection purposes. Crystals are power objects and should be kept respectfully covered except when in use.

Transformation Properties

Crystal practitioners and healers profess that different crystals have unique transformation properties. To touch on a few:

Clear Quartz Crystal—Enhances the crystalline properties of blood, body, and mind. Activates and enhances pineal and pituitary

glands. Aligns the etheric and emotional bodies. Stimulates brain function. Amplifies thought forms. Fills the aura and chakras with light. Full spectrum energy activates all levels of consciousness. Dispels negativity in one's energy field and the environment. Receives, activates, stores, transmits and amplifies energy. Excellent for meditation and healing. Enhances inter-dimensional communication and also communication with Higher Self and Spirit Guides. Aids emotional stability and brings goodness on every level.

Amethyst—A variety of quartz. Comes in purples, reds, violets, pinks and grays. Strengthens endocrine and immune systems. Enhances right brain activity and pineal and pituitary glands. Powerful blood cleanser and energizer. Helps mental disorders. Purification and regeneration on all levels of consciousness. Transmutes one's lower nature into the more highly refined aspects of the higher potentials. Physical representative of the Violet Ray of alchemy and transformation. Cuts through illusion. Enhances psychic abilities. Excellent for meditation. Aids channeling abilities. Calming, strong protective qualities. Healing Divine love, inspiration, intuition. Aids alcohol and drug recovery, alleviates headaches and migraines, relieves stress, and brings inner peace.

Red Garnet—Strengthens, purifies, vitalizes and regenerates bodily systems, especially the bloodstream. Stimulates the pituitary gland. Amplifies love and compassion. Enhances imagination. Repels disharmonious people from the aura energy. Draws Earth energy into the body. Stimulates life forces, causes acceptance and balances in the incarnation. Boosts sexuality and fertility.

Herkimer Diamond—A type of quartz crystal found in upstate New York. Reduces stress by bringing harmony within, with others, and with one's world. Balances and purifies energy within the body and mind. Similar qualities to clear quartz. Power amplifier. Enhances inner vision and mental clarity. Increases awareness of dreams and is considered a dream crystal. Stores thought forms and information. Helps align the physical and spiritual selves.

Lapis Lazuli—Strengthens the skeletal system. Activates the thyroid gland. Releases tension and anxiety. Augments strength, vitality, and virility. Facilitates mental clarity, brings illumination. Enhances psychic abilities and communication with the Higher Self and Spirit Guides. Creative expression. Heals mental body damaged from old traumas in this life, reprograms the mental body, and facilitates healing. Works well with Rose Quartz.

Meteorite—Also called tektite. Expands, aligns, and clears chakras. Helps reveal past lives from other planets and galaxies. Enhances connection with extraterrestrial energies, and brings messages from the stars that we on Earth are neither alone nor abandoned by the Universe. Protects our auras from negative alien energy. Expands awareness.

Rose Quartz—Aids the kidneys and circulatory system. Increases fertility. Eases sexual and emotional imbalances. Helps clear stored anger, resentment, guilt, and jealousy. Reduces stress and tension, cools hot tempers. Enhances self-confidence and creativity. Aids development of forgiveness, compassion, love. Called the love stone. Heals the emotional body and aids learning to feel one's own emotions. Fosters acceptance, inner peace, forgiveness and self-forgiveness. Eases fear and soothes grief.

Rutilated Quartz—Regeneration of tissue throughout the body. Enhances the life-force. Strengthens the immune system. Stimulates brain functions. Eases depression. Facilitates inspiration and increases clairvoyance. Highly electrical, more intensity than clear quartz. Pierces through layers of physical, emotional, and mental density. Transmutes negativity. Enhances communication with the Higher Self and Spirit Guides. A powerful healer. Expands the transmission of light, positive energy, and information entering the aura. Clears and expands chakras.

Smoky Quartz—Strengthens the adrenals, kidneys, and pancreas. Increases fertility and balances sexual energy. Aids depression. Mildly sedating and relaxing. Dissipates subconscious blocks and negativity on all levels. Grounding and centering. Excellent for mediation. Enhances dream awareness and channeling abilities. Creates acceptance of the body and the earthplane. Promotes walking softly on the Earth Mother and encourages Earth awareness and responsibility.

Physical Attributes

The physical attributes of crystals add to their interest and sense of mystery

Clusters—Clusters are two or more crystals naturally and physically attached to one another. A cluster may contain two crystals or several thousand of various sizes. Clusters with one large and many small crystals (hens and chicks) seem to take on feminine healing characteristics. Crystal villages are popular in today's world

and can be found in nature or for sale in shops. Usually a stone thunder-egg—small as a hand or many feet tall—is cut in half to expose the interior, where clusters of crystals have nested since the earth was a child. Crystal clusters are sometimes harvested as individual stones, because a cluster can function as one part, or a whole entity.

If you have a crystal cluster, consider having it evaluated by a crystal practitioner or Medicine Person. Each cluster and each crystal on a cluster is unique and has a special purpose.

Inclusions—Developing deep within crystals, inclusions usually appear as wisps or feathers, but may also be rainbows, washes of color, mirrors, phantom shapes, or recognizable forms. Native American crystal healers seek stones with eagle shapes encased in them. These are especially sacred and kept in Holy places. A group of Alaskan Natives carried a large amethyst crystal off Mount Denali that must have weighed a hundred pounds and gave it to my sister-in-law as a thank-you for a healing she did with their people. One can actually see dinosaur-shapes within this crystal's cold heart. Crystals with inclusions are more intense than totally clear ones and their energy is magnified. Water, for instance, is a natural purifier and intensifies the object's healing attributes.

Left Hand or Right Hand—Strange as it sounds, crystals have a handed-ness property. *Left-handed* crystals have spirals of electrical energy rotating within them in a counter-clockwise fashion. They're considered female crystals and have a tendency to absorb energy. Because of this, a female crystal can take-in positive or negative energy, so it must be wrapped at all times when in public.

Right-handed crystals have spirals of energy rotating within them in a clockwise fashion. They're considered male crystals and have a tendency to give-off energy. These, too, should be wrapped when in public because you never know how your crystal might affect someone else. You can determine the gender of your crystal by a simple process: Dangle it from a string or thread about two or three feet long, being careful to hold it motionless. After a short while, the stone will begin to rotate on its own: Female counter-clockwise, male clockwise. The amount of energy it contains will determine the rotation's speed and diameter.

My Watai is a marvelous female crystal. I took her with me to Alaska one time, and when I dangled her, she'd absorbed so much energy she practically flew off my hand. I had to wrap her back up,

not knowing what might happen.

Double Terminated—Most crystals sprouted from rock surfaces in a cave or on a cliff face. Occasionally a crystal was allowed to grow free of a base, although this is extremely rare. Double terminated crystals are among the most powerful, complex and useful. They are unique because they manifested in a whole, perfect crystal form. The American space program has a plan to grow double terminated crystals in its space station. In single terminated crystals, energy moves from one end. Double terminated crystals are like two-way streets. Energy enters and leaves both ends. These are the best crystals for seeking visions, healing, and transmitting energy.

Size and Clarity—We learned above that a crystal with inclusions generally has more power than a totally clear stone. Also, as an accepted rule, the larger the crystal—the more power it has, due to increased volume capacity. This isn't always the case, as there are a few other factors to consider.

A small, activated crystal could have more power than a large non-activated crystal. Regardless of the size, crystals can become dormant or asleep until they're activated. What activates a crystal is a topic of much discussion.

Crystal people have told me they power-up their gems by finding a rock partially out of water and tapping their non-pointed ends on the rock several times. A Medicine Woman I know takes her crystals out four times a year; on the two solstices and the two equinoxes. She places them outside in her flower garden, points-up, overnight for cleansing and recharging.

Some say you can activate a crystal by setting it outside in a thunderstorm or storing it with other crystals or special stones. Others say a sudden surge of mental or spiritual energy can awaken the rock. A third concept is that the crystal can activate itself on its own volition. And like people or batteries, it may need time to recharge. A crystal practitioner recently inspected my Watai and told me it's now in a dormant stage because it recently worked hard to keep me heading in the right direction, mentally and spiritually.

Crystal healers and practitioners can actually program a crystal for specific purposes, depending on the needs of its owner. If a person is suffering a major physical illness, a crystal can be programmed to heal. If a person is in a state of great joy and happiness, a crystal can be programmed to store that positive energy and return it when called upon. In general, programmed crystals have more power than

non-programmed.

The double terminated crystal, regardless of size, is more powerful than any single terminated crystal.

Mirrors — An interesting inclusion in a crystal is a mirror. Some experts say the mirrors are almost microscopically-thick sheaves of metal, like silver or aluminum, that help the crystal retain and modify energy. Usually this coating is protecting some type of existing Higher Order programming and is found in what are called library crystals. With more memory capacity than the most amazing micro-chip, a library crystal can hold tremendous amounts of universal knowledge.

Rutile — This material in a crystal is actually titanium dioxide. It forms pathways toward transformation. Rutilated crystals have strands inside that often resemble human hair.

Natural versus Faceting — There is no general rule about which has more power — a natural crystal or one that has been faceted, carved, or tumbled. A smooth crystal ball doesn't occur in nature, but from ancient times has been considered an important talisman in crystal art. Watch for quartz crystals with a somewhat opened V-shape bevel on one facet. It's believed the crystal witches of Atlantis were the only ones who ever marked their crystals this way. A stone that has been improperly faceted has had its inherited balance destroyed and may be of little use.

Chips and Cracks — Chips and cracks are part of the natural process of crystals. They are visual indicators of the information gathered within and can add to the gem's interest and beauty. Rarely do chips and cracks affect a crystal's over-all performance. A double terminated with a broken end still has the abilities of double termination, with energy flowing in and out.

How Can a Crystal Help a Person?

This may sound strange, but my quartz crystal necklace, my Watai, has often served as a companion for me. When traveling, I always wear it around my neck or hang it on the vehicle's rear view mirror. I keep it in my pocket for luck when I'm in a casino. (I recently won a $40,000 jackpot, and I thanked my crystal.) Mine is a feminine power crystal that attracts energy, so I keep it out of sight. I don't need the world's negative energy stored in my gemstone.

Crystals can be a great help for meditation. Holding a crystal helps the practitioner depart from the corporal world with greater

ease. Many practitioners say a crystal can help them move through levels of consciousness and communicate with other people and creatures of nature.

One of my daughters visited a Crystal Healer to help her deal with physical and mental issues. I observed a few of the healing sessions and saw the improvements first hand. Because of this amazing power, my daughter is training to become a Crystal Healer herself.

The special properties of crystal balls are not a myth, and valid psychics and fortune tellers use them to foresee events or discover hidden knowledge. This is called divination. The meta-physical properties of crystals will always be debated, but it's a proven fact that quartz crystals are more than a passing fad. These gifts from nature are an ancient tool used by early civilizations to improve physical, mental, and spiritual well being. Contemporary science uses crystals in lasers, medical equipment, machinery, watches, and intricate parts of weaponry.

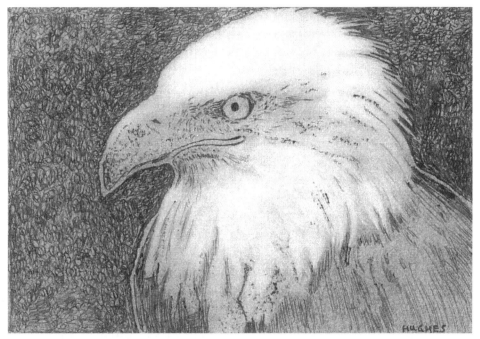

Bald Eagle

The Basket
Psah'-koh-kah

At first, they rise from Mother Earth
Open their eyes and seek the sun.
Their arms stretched out in painless birth.
Awaiting the touch of the One
Who can foretell their future worth.

The Weaver picks the very best.
Her eyes can see what will become.
They soon will be her special guest.
Soft and smooth 'tween finger and thumb.
Brothers alike ... they gently rest.

She splays them out and makes a plan.
Her mind can see the finished rows.
The reeds themselves guide her soft hands.
Before her eyes the child grows.
Embraced as one ... more than a strand.

Row on row ... around and around
Through and over ... back and again.
It slowly rises from the ground
Never asking, What might have been?"
Only wond'ring, "Where am I bound?"

Now satisfied, She eyes her art.
Each reed holds tight to his brother.
They know they're just a single part
Of the love of their new Mother.
A manifest of Her warm heart.

Just a basket? Look deeper.

Ha-Gue-A-Dees-Sas
2007

Chapter 11
An Ancient Oral Tradition:
American Indian and Alaskan Native
Myths, Legends, and Songs

The magic of the spoken word has enriched every First Nation. Most stories, myths, legends, or songs had a purpose and a message for the listener; but some were just for fun. In this way the culture and history of the People passed from season to season, connecting the generations.

Significant tribal events and family stories were recorded through pictographs on tents, peeled bark, rocky outcroppings, and cave walls, but no American Indian or Alaskan Native group had an alphabet until well into the eighteenth and nineteenth centuries. These written letters and diacritical marks were an effort to transcribe spoken sounds into a consistent visual format—and eventually a printable format.

Each tribe had its own creation story. Most glorified the people telling the story and belittled their neighbors. The stories were filled with parables to make them more relevant and understandable. They supplied answers to age-long questions, confirming a direct link between Great Creator and the Native Nation; that powerful animals such as eagles, bears, ravens, and cougars were part of the tribal family; and that the Earth Mother had a special affinity for them and took great interest in their comfort and survival.

Here are samples of the stories and songs I've shared while visiting school children and giving workshops on storytelling.

The Osprey and the Raven

Ha-Gue-A-Dees-Sas

Long before the Two-leggeds walked this land, Brother Raven silently glided over the dry sea of grasses, his black, glistening eyes watching for quick movements that would tell him the Mouse People were foraging for food. Because of the relentless summer heat, hunting had been poor. The bird felt the weakness and discomfort of hunger — an all too familiar feeling as of late.

Gorged and sleepy, Grandfather Osprey sat listlessly in a cedar tree that once shaded the riverbank. The drought had taken its toll on Sister River. Where normally a cool, rushing stream laughed, now rocks and sand lay exposed to the hot, merciless drumming of Father Sun. Low water levels flow caused the Fish People to crowd together in the dwindling pools, irritated, aggressive, ready to strike at anything. Once bright and shining, their scales were bruised and mottled, dull from the warm water and fights with each other.

The black, shiny Kwa-gok swooped past the stream and landed on the limb next to the sleepy osprey. "I wish I were like you, Grandfather. Look how easy it is for you. Your domain is a land of plenty. All you have to do is fly down to the water, put your claws in, and out comes a meal. Your family is well-fed and clear-eyed."

"Don't be a fool," the Fish Hawk said. "Creator God made the Four-leggeds for you to hunt and the Swimmers for me. Do not be covetous of what He has given me. Has He not always cared for you? We are asked only to trust His eyes are upon us."

The Raven looked disdainfully at his neighbor. "My, aren't we righteous today? It's easy to be gracious when your stomach is not grumbling."

"Join me," Grandfather Osprey responded, ignoring Raven's comment. "I have plenty to share."

Brother Raven shook his head and flew from the tree. Wings outstretched, he studied the stream below. The Fish Hawk's domain teemed with life. Circling lower, he said, "Ah, there's a likely shadow."

Dropping down to the river's surface, he clumsily reached into the water. With a croak of shock he tumbled beak-over-tail feathers into the stream's waiting arms. The tree root he grabbed instead of a fish had long ago won its battle with Sister River and was not about to give way to a foolish raven.

Flapping furiously, Raven vainly tried to lift himself from the sluggish stream. Exhausted and soaked to his down feathers, he sank into the water where the Fish People waited for a meal.

"Help me, Grandfather!" he sputtered.

Grandfather Osprey dove toward the terrified bird. Reaching out with steel-like claws, he gouged deeply into Raven's shoulders. Black feathers flew everywhere. (This is why today when ravens get old they lose feathers from their shoulders.) With powerful strokes, Osprey lifted Raven from certain death. Raven screamed in pain, not only from Osprey's grasp, but from the razor-sharp teeth of a large bass that clung to one of his claws. A sickening snap signaled the loss of one of Raven's toes. (This is why some Ravens and Crows are seen today with four toes instead of five.)

Grandfather Osprey gracefully carried his bruised, wet friend from the water and lowered him to the river bank.

Raven lay whimpering from pain and the indignity of his situation. His beautiful black feathers were blood-streaked and matted. His claw and shoulders throbbed. He was absolutely miserable.

Osprey hopped onto a nearby stone. "The Creator did not make you to be a Fish Hawk. You are perfect in every way for what God had in mind for you. If you covet me and what I am and have, that will only lead to folly."

"I know," sighed Brother Raven. "I know."

Touch the Sky
Ha-Gue-A-Dees-Sas

A mother field mouse, (sin-teh'-sh'dah in Dakotah Sioux), found a home for her three babies under a moss-covered tree that had fallen long ago. She made a comfortable bed of dried grass, and the little ones were safe and cozy in their den. When she needed to leave her children to forage for food, she especially worried about the young boy mouse. He was curious and didn't always mind his mother.

On occasion, other mice dropped by to discuss the difficulties and dangers of staying alive in the big world. Hawks and Ravens circled the sky, looking to swoop down on them, and many hungry Four-leggeds were always nearby, watching for a quick meal.

After a hard day of foraging, the mother mouse returned home to find her two little girls asleep and the young boy eager to hear about her adventures. His questions and antics were annoying, especially when he asked, "Mother, what is the sky?" She was tired and in no mood to explain anything, so she pointed upward and replied, "All you need to know is that it's up there."

The little boy mouse settled down, and when he looked up, all he could see was the bottom of the fallen tree. "So that's the sky," he said. "I wonder if I could touch the sky." He stretched as far as he could, but his paws didn't quite reach the overhead tree trunk. He crouched down, then jumped with all his might, and his claws barely swept across the rotting bark. When he landed, he tumbled onto his back, and with a wide smile began to sing:

Yah-kee Oh-oh-oh
Moh-zha nah lay.
A-a-a-a
Pay Zhay Nah Keesh-kay
Sha-nah Neek Nah-zhee
Ka-a-a-y
Moh-zha nah lay.

Which in Chicamacomico means:

"I am the most wonderful creature of the Earth Mother. I can touch the sky."

Apache Wedding Blessing
Ke-che'-yu-zah-pe Yu-wah'-kon - (Apache)

Now you will feel no rain,
For each of you will be shelter to the other.
Now you will feel no cold,
For each of you will be warmth to the other.
Now there is no loneliness for you,
Now there is no more loneliness,
Now there is no more loneliness.
Now you are two persons
But there is one life before you.
Go now to your dwelling-place
To enter into the days of your togetherness.
And may your days be
Good and long upon the Earth.

Holy Song

Oh ye people of this tribe
Be renewed now, for I heal you
Be ye well

Oh ye people of this tribe
Be renewed now, for I heal you
Be ye well

Thus has our Great Father said
Thus he spoke!

Be renewed now, all ye people
Be ye well

Wah-kon' Oh-doh-'won (Dakota Sioux)

Oh-yah-teh-wan wash-ti-ca
Wan-na pi-ya wa-ka-jhay-lo
Ah-eh-yoh

Oh-yah-teh-wan wash-ti-ca
Wan-na pi-ya wa-ka-jhay-lo
Ah-eh-yoh

Wan-kan-ta Tun-kan-si-la
He-yah cah

Wan-na pi-ya oh-yah-the-wan
Ah-eh-yoh

The Story of Cannibal
at-the-North-End-of-the-World
(Kwakiutl)

Long ago, when spirits roamed the earth in people form, four human hunters trekked deep into the Pacific Coast Range of present-day British Columbia, Canada, in search of mountain goats. The early spring weather was cold and rainy and the hunters were exhausted and soaking wet. Pausing to rest, they saw a massive hut in a secluded valley thick with spruce trees. They hurried inside the hut to escape the rain. While exploring the rooms inside, they heard an eerie whistling sound. Suddenly, a giant strode in from the back. Their host was the terrible Cannibal-at-the-North-End-of-the-World. He had gleaming red eyes and stared at the hunters, licking his chops in a hungry manner. Saliva dripped from his cavernous mouth. At his heels, with a great flapping sound, came his flock of man-eating birds: Hokhokwa, who crack open skulls to eat people's brains; Raven, who plucks out eyes and swallows them in one gulp; and Crooked Beak of Heaven, who drives men crazy. They represented the darkest side of uncontrolled human desire.

The hunters ran from room to room and eventually escaped the hut with their lives. But in fleeing, they took with them the secrets of the cannibal's power. They stole his masks, whistles, cedar bark apron, and his dances and sacred songs. When they returned to the village, they re-enacted their encounter—to the horror and delight of the people.

So began the annual rite of the Hamatsa Dance, the most venerated of all the Kwakiutl winter ceremonies.

The Cry of the Loon

(Micmac) This is a true story.

A young Micmac boy from northern Maine was given his first rifle, a .22 caliber Browning. He was proud of this possession and carried it everywhere. What good is a rifle if you can't use it? So the boy often wandered through the forest, ready to shoot a bear or a moose. Of course, there were no large creatures like that anywhere near the village. He occasionally shot at a squirrel or field mouse, but could never hit such a small target. He wasn't quite the Great Hunter he envisioned.

One afternoon while strolling beside a lake near the village, he noticed two large birds swimming off shore. They were as black as coal and shiny as glass. Acting on impulse, he raised the gun and sent a bullet flying in their direction. To his elation, one of the birds squawked in alarm, flapped its wings, and collapsed into the water. The other bird cried over and over, swimming around the dead creature in total confusion and wretchedness. The sound was so heart-wrenching, the boy turned and ran back to the village, knowing he'd done something terrible, but not exactly sure what.

That night, the boy had a vision. He dreamed he was sitting on the bank of a lake and a black bird with small white feathers across its breast swam toward him. As it reached the shore, the bird turned into a beautiful Indian woman in a black dress with a white shell necklace around her throat. The woman looked at him in great accusation and said, "Why did you kill my husband? We are loons and mate for life! Now I must go through the rest of my days lonely and empty." She began to weep.

The boy was completely despondent and choked out his reply, "I'm sorry. I didn't know what I was doing."

The Loon-Woman looked at him with great scorn and stated, "Because of what you did, for the rest of your life whenever you hear the call of a loon, you too will cry."

The boy is now a Grandfather for his tribe. Whenever he hears the cry of a loon, he cries also.

The Talking Stick
Ha-Gue-A-Dees-Sas

The talking stick has been used for generations by many American Indian and Alaskan Native tribes to provide a just, impartial hearing and an opportunity for speaking. The stick was commonly used in council circles to designate who had the right to talk. When serious conflicts or matters of great concern came before the tribe, the leading elder would hold the stick and begin the discussion. When he finished, he would hold out the talking stick and others would come forward and take it. In this way, the stick passed from one person to another until all who wished to provide input into the discussion had done so. In other settings, the participants might sit in a circle, and the stick would pass around that circle. If a member chose not to speak, he handed the stick to the person beside him. The stick eventually returned to the leading elder, who wrapped it and stored it away for safekeeping.

Some tribes used instruments other than a stick to designate who had the right to speak. A particular culture might use a talking feather or pass around a peace pipe, a wampum belt, or a sacred sea shell. Each of these implements denoted respect for open, honest speech and assured the speaker he had freedom and power to say what was in his heart without fear of reprisal or humiliation. Whoever had the talking stick held the sacred power of words. Only he could speak while he held the stick. The others had to remain silent.

The talking stick was always decorated, and each accessory carried an important meaning. An eagle wing or tail feather might be tied to the stick to give the speaker the courage and wisdom to speak wisely and in truth. Sometimes the talking stick also had a tiny down feather from the breast of an eagle to assure the words would come from the heart and that those words would be soft and loving. Other talking sticks might be decorated with stones, and their clacking sound reminded speakers that the Great Spirit hears the message coming from our hearts as well as from our lips.

To remind participants that all creation changes, California coastal tribes adorned their talking sticks with abalone shell, iridescent and ever-changing as it shimmers in the light. The Sacred Directions were represented by colored beads or yarn: white for the snows of the north, red for the sunrise in the east, yellow for the warmth of the south, and black for the night coming from the West. Some tribes included green for the Earth-Mother and/or blue for Father Sky. Each of these adornments held in the speaker's hands symbolized the powers of the universe. Hair from the magnificent buffalo was a rare and special decoration sought by many tribes and symbolizing the speaker talked with the power and strength of that great beast.

Honor followed the movement of the talking stick. Each speaker was reminded he carried within himself a sacred spark from the Great Spirit; and therefore, he was also sacred. To profane the talking stick with half-truths or lies was an unforgivable sin. If the talking stick passed to someone in a situation where he might bring dishonor to the emblems, he was morally bound to remain silent.

Today, the talking stick still has an important place in communication circles. Many Alcoholics Anonymous meetings use this implement. I was doing a workshop in Seattle, Washington, several years ago and used the talking stick process. None of the participants were Native Americans, and it was interesting to see how they reacted as the stick passed from one to the other. Some people actually showed a degree of fear when they received it. They were uncomfortable talking in a group setting and felt they were on the spot. I reminded them if they didn't feel like sharing, they could pass it on. A couple of participants couldn't wait for the stick, and once they held it, they had so much to say. I didn't grab the stick from their hands, but I wanted to. The reaction of one African-American woman was especially moving: She held the stick in front of her and began crying. She said in her home, people tried to talk over each other, and the loudest and most obnoxious won the right to speak. Because she was a quiet person by nature, she had no voice in her family. After the workshop I gave her the talking stick to take home.

The Origin of the Dream Catcher

Ha-Gue-A-Dees-Sas

Most villages of the northern plains Indians were transitory. More flexible than a Korean War M.A.S.H. unit or an Air Stream Trailer Club setting up for the winter in the Arizona desert, the entire village could be dismantled, mobilized, and re-assembled with great efficiency. The tribe needed mobility to follow migrating buffalo herds or seek better hunting, fishing, and gathering. Usually, berry picking and root gathering took place in different lands than hunting and fishing locations. Sometimes the people needed better pasture for livestock or a new water supply. At other times, they fled marauding bands of renegade Indians from other tribes. Villages were set up in special winter camp locations, usually in a protected mountain valley, away from the teeth of the mean wind and blowing snow of the flatlands.

The village chieftain would give the order to break camp, which leads us to the origin of the Dream Catcher.

Long before the White Man came onto the scene, Chon-SH'KAH SAH-pah (Black Hawk) led a prosperous village in the rich grasslands of the Sioux Nation in the north central region of the North American continent. He could feel the seasons changing and knew his people would soon need to move their camp to the sheltered arms of the sacred Black Hills for the winter. He didn't know a terrible early September blizzard was roaring out of the north. The buffalo sensed this impending crisis and had already started their migration southward. Chon-SH'KAH SAH-pah rode out to survey the latest location of the herd and was dismayed to find nothing but dry amber grasses beaten down by the massive beasts. The herd was nowhere in sight, yet the labor to prepare winter provisions wasn't completed. Upon returning to the village, he called the elders and the medicine man for a parlay to be held the following morning.

The village's horses and dogs were restless and irritable, a sure sign something bad was afoot. They sensed the cold, moist air quietly walking the land in their direction.

The first sign of the blizzard late that night was the slap-slap sound of tent flaps and decoration flags as the icy fingers of the breeze reached the village. Then followed a baleful whine as the gale force wind fought with the tent poles and travois platforms. The first spits of snow against the tents became a heavy, threatening cacophony more unsettling than war drums. It snowed … and snowed … and snowed.

The weather was so hostile the villagers couldn't leave their tepees for several days. Soon, the people ran out of water and food and the hungry children began to suffer. Native children are taught not to cry, but the babies knew no better and expressed their displeasure, day and night. Their plaintive wailing carried on the wind and broke the heart of Chon-SH'KAH SAH-peh. He lay on his bedroll, wracked with guilt. Had he sensed the weather change earlier, the village might have found shelter.

As he lay in the darkness, he heard a still, small voice. "My chief! I hunger."

"We're all hungry," he replied. Then he realized there was no one else in the tepee. He reached for a smoldering piece of fire wood, blew on it to make the embers glow, and held it up to see where the voice was coming from. Much to his surprise, a small spider had climbed down its web and was dangling near his face.

"My chief! My chief! I hunger," it repeated.

How much does a spider need to eat? The chief reached for a tiny particle of pemmican and offered it to the creature. It immediately ate the treat and asked for more.

When it's belly was filled, the spider said, "Now I will do something for you." And it scurried out into the winter night.

One by one, the unhappy babies stopped crying and soon the village was silent except for the last throes of the storm continuing toward the land of the Pawnees. For the first time in days, the chief rested.

The next morning, he heard startled sounds from the villagers. Over each baby's cradle board, a small spider web had been woven. The Medicine Man explained the web had magical properties and could trap bad dreams and nightmares before they touched the babies.

To this day, dream catchers are hung on the walls or suspended in the bedrooms of Native and non-Native children. We still believe this marvelous artifact helps our children sleep better at night.

Native American Death Song
Ha-Gue-A-Dees-Sas

Do not stand at my grave and weep.
I am not there—I am not asleep.
I am the cooling winds that blow.
I am the gently falling snow.
I am the whispering showers of rain.
I am the memories of a lonely pain.
I am the warming sun on grasses' dew.
I am the arms of love that caress you.
I am with the birds in circling flight.
I am the shine of stars on a clear night.
Do not stand at my grave and cry.
I am not there—I did not die.

Four Prayers of Goodbye
Doh'-pah Wo'-chay-ke-yah-pe

"Look to the stars" … and we will do the same.
"Remember your people" … and always know your name.
"Walk your path" … but know from whence you came.
"Come home to die" … for here there is no shame.

Ha-Gue-A-Dees-Sas
2007

Chapter 12
The Farewell

Bear Family

The U-Haul truck idled in the driveway, packed with the household goods of the Native Healer and his family. A promising new job in far-off Montana beckoned him toward adventure. His wife, a traditional Medicine Woman, walked up to me with a feather bundle in her hands bound with red and black yarn—the sacred colors for East and West.

"Hold this," she instructed. "This will help you pray. The big feather on the bottom is an eagle feather. We give it to you for strength. The black feather next to it is from Brother Raven. This is our prayer to you for wisdom. See the striped feather? That is from my power animal, Sister Hawk. It is in the bundle for protection. The small orange feather is from the Flicker-bird. It stands for joy and is also a "doctor bird."

Then her face clouded over and tears glistened in her eyes. She held out a large, plain, dark gray feather and studied it for a moment.

"This is from a Canadian goose. It is our prayer that you will always be able to find your way home. No matter where you travel, this feather will always help you return to your roots."

The Medicine Man shook my hand and then motioned us to take a short walk with him. Always the teacher, he began his last-of-all lessons: "Remember Our People's farewell. The first part is *look to the stars.* This is to remind you that no matter where you are on the Earth Mother, each night as friends look to the sky they see the same stars and think of each other.

"The second part of the Farewell is to *remember your people.* Do you notice every time we met Natives, one of the first questions is, "Who are your people?" We have become a nomadic race because of persecution, prejudice, and economics. Reminding ourselves of Our People helps us connect to our roots and brings back those fond memories. We walk the Earth Mother as a remnant of a mighty and civilized race. As long as we are alive, hope lives that we will once again gain dominion of this continent.

"Next, remember to *walk your path.* It is your right to pursue your own fortune and destiny. Creator God put you here for a reason— and that is a good thing. But also do not forget we're a part of a greater social structure. We need to fit in wherever we're living. I am affirming to you that you represent your People as you wander this changed land. Endeavor to be a blessing so people will think well of you, and of all Native Americans."

The Medicine Woman became swept up in the emotion of the parting. She took the Canadian goose feather from my hand and studied it for a few moments. "Last, *come home to die.* You know we believe the soul of a dead person will walk the Earth without peace forever unless he or she can return home. When the time comes, you will know where home is."

My walk with the Medicine Man and his family enriched my life beyond measure. Each adventure is exciting and life-giving. Like so many mixed-race Two-leggeds, I am astride two worlds—Native and Euro-American—the ancient past and the Here and Now. Yet, I feel rooted and comfortable in the knowledge of who I was, who I am, and who I am becoming.

◊◊◊◊

Frog

The Cricket
Te-oh'-sh'dah-nah

Your sweet love song touches my heart.
A familiar voice from afar.
And then the cacophony starts.
To welcome night's very first star.

There's a secret only I know.
The power of your gentle hum.
The day departs … the darkness grows.
If you don't call … night will not come.

Ha-Gue-A-Dees-Sas
2007

Chapter 13
Your Own Spiritual Journey

This book has been an odyssey for both of us. Now let's take a moment to consider what we've learned and how this information might help your personal journey.

What Have We Learned?

We now understand that Native American Spirituality is an ancient, sacred system of faith handed down from before the dawn of time through prayer, stories, songs, dancing, myths, and legends transmitted word-to-ear, from elder to youth. It may well be the oldest religion on this planet. Despite hundreds of years of concerted effort by dominant societies to silence these precious words, they have survived. And they still provide nourishment to those who wish to believe. Do these beliefs resonate with you? Would you like to learn more?

We've learned to appreciate the time-honored rituals of this complex, esoteric religion. We know about sacred rites, such as smudging. We recognize the sweat lodge as an ancient temple, with prayers and songs practiced within. We understand the training of Medicine People and Native Healers far exceeds the regimen and deprivations priests and ministers undergo to become leaders in their religious communities. Does this appeal to you?

We've heard a possible explanation of why certain places call to us or feel different when we visit them. Our planet has many Power Centers, and our inner selves are in tune with their magnetism. Traditional Natives knew the power centers and high places in their environment and made Vision Quests and Power Quests part of their spiritual and emotional growth. Each of us has a spiritual battery that gets rundown at times. Visiting a power center helps us recharge and gain energy to face the trials of our corporal existence. Your spot may be a lake, a mountain, or a secluded beach; but once you find it, you'll know. You'll be drawn to that location. Allow

yourself time to go there.

Have you found your Watai? Keep looking for that special rock to keep in your pocket or purse because it seems like the right thing to do. You'll find yourself holding your rock, examining it, perhaps meditating with it. Traditional Natives talk about the Rock People and special powers possessed by stones and gems. As you read about these properties and associate with crystal practitioners, you'll be amazed. I always keep amethyst crystals around, because they make me feel good and help me relax. Honest!

After reading the chapter on warriors, did you recognize yourself? Do you hold a sense of caring and protection for others at the center of your being? Does your inner power give you the strength to bring honor to those under your care? Each day brings new battles to fight, and we need warriors who will carry the standard to victory. Do you feel the call to arms?

We know the circle and its four parts are vital to Traditional Native life. So simple, yet so complex. Much of what Indian children needed to know was symbolized by creating a circle with their hands. If we can embrace the concept of the circle as it applies to us, then the sting of death is no longer a fearful thing. We can approach that logical and sensible next step in the Circle of Life with relief and confidence. We can become death affirming rather than death denying.

A spirit-animal walks with each of us, whether we realize it or not. I find that idea comforting and wish the same for you. We learned different ways to identify our totem or spirit-guide. How delightful to know a protector stays always with us—a true companion who never turns away, even when we're unkind, insensitive, or just plain stupid.

We learned those who believe in Native American Spirituality are never alone. They are members in equal standing of the biggest family of all. The Two-leggeds, the Four-leggeds, the Crawlers, the Flyers, and the Swimmers are all related. Even inanimate objects like trees and rocks are considered People with spirits and are worthy in the Creator's eyes. Each family member has the same wellspring, our Earth Mother, so we are all brothers and sisters. This Mother of All Mothers loves every one of her children and is always willing to hold them in her arms when needed. In the eyes of a Traditional, there is no only child or lonely child.

Do you feel the need to become more immersed in Native American Spirituality? An important first step is praying to the

Creator, asking him to help with your quest for enlightenment. Next, begin reading about the topic and researching what practitioners have to say. My own spiritual-advisor, Robert Lake-Thom (Medicine Grizzly Bear Lake) has written four books on the subject and has his own website:

www.nativehealer.net

His wife Tila Starhawk Donohue created an important book from the woman's point of view. The references I list at the end of this book are a tiny fraction of what's available. We are fortunate to have the Internet at our fingertips and public libraries in our communities as resources. But this is only the beginning.

I suggest you become personally involved with the Native communities in your area. Every state has at least one Indian reservation, and some have many. Visit their Holy Ground and see what you can learn. Most large cities have an urban Indian center. Even the Indian casinos can be a good first start. Get to know people by demonstrating an interest in them. Let the centers know you'd like to volunteer in any way they need you. Many colleges and junior colleges have extended learning classes on Native American topics. Sign up and learn all you can. Watch for cultural activities like powwows and rendezvous, and take part in them. Try to attend events, such as American Indian or Alaskan Native dance, drum, or drama groups. Visit with the performers and ask questions. If you're aware of demonstrations or sit-ins for Native rights or issues, join the crowd. As you become known and accepted, you'll begin learning more about the Medicine People and Native Healers. Someone may be willing to mentor you as you continue your journey toward Native American Spirituality.

In her book *Lakota Woman*, Mary Crow Dog talks about Skins (Indians). She reminds us this description refers to what's inside us, not our skin color. Being Native is inclusive rather than exclusive. We all possess the potential to be welcomed as kinsmen. The pathway to Native American Spirituality is available to each of us if our hearts are right, our spirits are gentle, and our motivations honorable.

May the Creator know your name.

Ha-Gue-A-Dees-Sas

◊ ◊ ◊

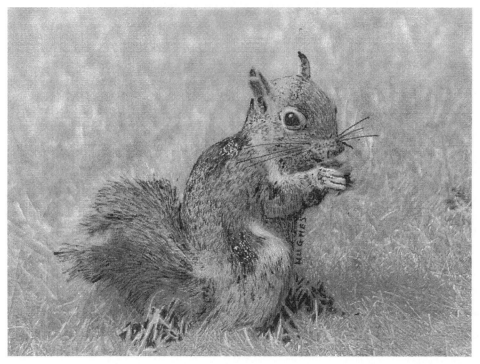

Squirrel

Chapter 14
How Can You Find Your Totem?
How Will Your Totem Find You?

Traditional Native Americans know that each human has a spirit animal to walk through life with us. We may be unaware of this, and we may not care—but that doesn't alter the facts.

Totems reach out to you during times when you may be receptive—meaning you aren't wrapped up in the trials and tribulations of daily activities. These magnificent creatures are always at your side and work tirelessly to develop a familial bond with you. Your Totem or Spirit Animal will take at least seven different pathways in an effort to reach you:

Environmental Preference

Spirit Animals identify with the places where they lived during corporal life. This will be reflected in a fondness for that environment. For example, if your Totem is a dolphin, you will have a special love for the ocean.

Personal Characteristics

As you walk with your Spirit Animal, you'll find yourself taking on characteristics of that creature. For example, if your Totem is a deer, you'll become more gentle and family oriented.

Personal Preferences

The artifacts of your life are quietly influenced by your Spirit Animal. For instance, people who have an eagle for a Totem often display pictures of eagles in their homes, wear eagle jewelry or accessories, and might even have an eagle tattoo.

Affinity Toward the Animal

As the bond between Totem and Two-legged strengthens, you will become a strong voice for the preservation and safekeeping of that corporal animal.

Supernatural Communication

Your Totem reaches out to you while you're in the dream world, deep meditation, or another state of altered consciousness, even though you may not remember these encounters.

Other's Perceptions

People in your work and social life will describe you in animal terms. They might say you're "busy as a beaver" or "angry as a bear." This could be a hint that your Totem is touching you with its special characteristics.

Traditional Native Medicine People will be able to see your Spirit Allies and may choose to let you know what they discern. I was asked to talk with the entire student body of the high school on the Spokane (WA) Indian Reservation about the value of continuing their education and trying to steer clear of drugs and alcohol. Later, during the honor meal, one of the Tribe's Medicine Men sat by me and said he saw two large Spirit Birds, a Raven and a Hawk, drop out of the heavens and land on my shoulders when I used my feather bundle to pray for the children.

Familial Bonding

Your Spirit Animal wants to welcome you into its family as an honored brother or sister. He will communicate with corporal creatures of the same species. Spirit wolves will use dogs as a communication link. A cougar Totem will reveal itself through everyday house cats. As you gradually recognize the connection, you will no longer feel alone or abandoned on this earthly plane.

An amazing thing will happen when you realize your Spirit Animal has bonded with you. Suddenly you'll realize you're part of the family. The paralyzing sense of being alone and forgotten is no longer a part of your life-way.

Common Totems in North America

The most common Totems acknowledged by Native Americans and Canadian First Nations are listed on these pages. Scientific taxonomy and Dakotah Sioux names are added when appropriate. In no way does this sample imply these are the only spirit animals prowling the mystical world. North American birds, reptiles, and mammals such as polar bears, seals and sea lions, moose, wild boar, and many other serve as Totems to fortunate Two-leggeds.

Magnificent creatures across the globe, such as elephants, lions, tigers, sharks, gemsbok, and walruses have similar roles on other continents.

If you don't recognize your Totem from the following activity, don't feel you lack an animal spirit ally. Chances are, a family of Four-leggeds, Flyers, or Swimmers will emerge as a result of your survey, but your specific animal may not be identified. The important things is to extend your spiritual arms in an effort to embrace that marvelous creature.

Badger or Wolverine

(Taxidea taxus or ghoh-KAH) is a good sign recognized by almost all Native American nations. He or she is a furious protector of the family and home. Badger Totem is considered courageous, tenacious and defensive, yet nurturing, gentle, and healing toward its loved ones. Badger connects its human to the spirit of the earth and brings the ability to see beneath the surface of issues.

Bear

(Ursus or mah-TOH) is always a good sign and a source of special power strongly influenced by Grandmother Moon. Those with a Bear Totem possess, or have the potential for, wisdom, insight, introspection, discernment, discrimination and especially healing others' minds and bodies—especially kidney problems. Bears have a special place in the heart of the Creator and have been called upon to bring messages for the Two-leggeds and even serve as ferocious deliverers of His retribution.

Beaver

(Castor Canadensis or CHA-pah) can be a messenger Totem of good news or of conflict and confusion, so he or she isn't always a good sign. Beaver is industrious, hardworking, and intelligent, but gets wrapped up in his or her own affairs and may seems insensitive to the issues of its human. Beaver can teach the therapeutic value of breathing and breath control and help with the connection between reality and the dream world.

Blue Heron or Crane

(Ardea Herodias or ho-KAH) is a symbol of peace, stability, and harmony. When the heron asserts itself as your totem, it implies

you're progressing or evolving toward a special destination in the spiritual, emotional, or physical world. It reminds you to stand on your own legs with grace and tact. If you can find time to meditate on the blue color of the heron, you will receive insight as to why it entered your life.

Bobcats, Lynx, or Smaller Feral Felines

(Felis rufus or e-H'MU-sin-teh-ne-cha) are strong hunters and protectors of their Two-leggeds. Their Totem power and medicine can be used for good luck and success in seeking sustenance. They are especially aware when their human is being stalked by an enemy, either physically or spiritually, and are great allies in corporal and mystical warfare. Bobcat seems to find humans who prefer solitude and distance in interpersonal relationships. He is a great confidant and friend.

Buffalo or Bison

(Bison bison or tah-TON-kah-h'cha) is a marvelous Totem and rather rare in today's world. Buffalo meant survival for the Indians of the north central area of North America and were worshipped as a special gift from the Creator's own hand. Because of this, Buffalo Totem is a unique connection between the corporal and spiritual worlds, possessing strong power and the ability to convey messages in both directions. If you have a Buffalo Totem, you are potentially in a position to learn those powers and assist humankind in its struggle to relate more closely to the Divine. Buffalo is also a grounding totem and helps its human find the synchronizing aspects of life.

Cougar or Puma

(Felis concolor or pah-HA-ton-kah M'NAH-zah) is the most powerful Totem of the North American cats. Similar to Bobcat mentioned above, Spirit Cougar is a magnificent protector of its Two-legged. It is deeply respected by Native Americans, and those who sense a Cougar or Puma is a person's Totem will show deference toward that person. Cougar Totem power is a two-edged sword and can be wielded for good or evil.

Coyote

(Canis latrans or sin-TAY-poh) as a Totem is a conundrum. Coyote Totem is full of magic, special powers, hidden wisdom,

and teachings. The Two-legged who has Coyote as his spirit ally is especially blessed, because he or she can learn about the meaning of life and grow spiritually. That person can also discern when another is being straightforward or speaking with a forked tongue. However, Spirit Coyote is also a trickster, so this omen requires careful study and can change from time to time, person to person, and from situation to situation.

Deer

(Odocoileus or TAH-cha) is always a good and gentle power, especially valuable to a Two-legged who has experienced more than his or her share of disappointment and sadness in life. As a person grows in the relationship with the Deer Totem, that marvelous creature teaches the importance of balance and grace in living and can become another set of eyes and ears, providing a deeper understanding of the true purpose for walking this world. Through meditation and dreams the Spirit Deer can provide glimpses into the importance of family and the subtleties of future events. Forewarned can be forearmed.

Dolphin or Porpoise

(Tursiops truncates—not found in Dakotah nomenclature) is a splendid Totem in every way. Many feel the dolphin has a special relationship with humans, manifested by love and concern for our well-being. They truly are our relations. Countless times, Dolphins have rescued humans in distress, and this also occurs in the spirit world. Your dolphin Totem is always with you, offering companionship, good power, luck, protection, and guidance. Strangely, dolphin medicine is especially effective for breathing problems.

Eagle

(Haliaeetus leucocephalus or wom-BLEE) is universally considered the most desirable Totem. The eagle Totem represents protection, wealth, wisdom, foresight, strength, creativity and spirituality—all qualities of great value to human beings. If you're praying or meditating and a Spirit Eagle comes to you—this manifestation guarantees the prayer has reached the Creator. If you're striving to achieve the level of consciousness for out-of-body travel (also called astral-projection or soul travel), eagle Totem will

encourage you in this endeavor and be your flying companion once you're able to travel. Eagle especially seeks out humans who live near water.

Elk

(Cervus elaphus or hay-HA-kah) is always a good force, as with deer. However, elk has more raw power and stamina and can stand long and strong for the protection of its Two-leggeds—especially women. The power and spirit of elk Totem can help women deal with female problems and will assist all humans in overcoming fear, anxiety, sexual problems, and plain old bad luck. Elk can predict your future endeavors and help you move in the right direction.

Fox

(Vulpes fulva or shoon-HE-nah) This Totem provides cleverness, intelligence, and wisdom for its Two-leggeds. As the fox is a smaller member of the canine family, this creature survives by relying on wit and quickness. Occasionally fox Totem is a sign of danger or sickness, but it has good power and can reverse the effects of those negative situations and serve as an able guardian. Spirit Fox also is a manifestation of pride, loyalty, and regality.

Frog

(Rana Pipiens or h'nah SH'KAH) is an unusual totem, possibly the only amphibian in the group. If you're affected by the phases of the moon, frog totem may be working in your life offering you the opportunity for abundance and fertility. Many cultures believe frog voices call forth the rain. In the spirit world, frog can teach you how to clean up the emotional waters you're floundering in.

Canada Goose

(Branta Canadensis or sog-DAH mah-GAH) is a marvelous Totem that teaches important lessons about the need for supporting each other and becoming more organized. Goose Totem reminds us that seasons continually change, which reinforces the Creator's plan of infinite variety. Of equal importance, Spirit Goose brings the promise that we will always find our way home.

Hawk

(Accipiter Cooperi or chon-SH'KAH) The spirit hawk is a good

sign and a powerful protector. Confusion surrounds the hawk totem, because it conveys dual messages, depending on what kind of hawk is trying to communicate with its human and whether it's hunting, circling, nesting, or displaying a defensive posture. Brother Hawk is a constant companion, alert to trouble in such a strong way that even unbelievers feel a sense of watchfulness and a premonition of danger. People with hawk totems are often visionaries with special gifts to anticipate the future and find appropriate pathways to get there.

Hummingbird

(Trochilidae coraciiformes or tah-NAH-he-nah) is the smallest Totem, and perhaps the greatest. Hummingbird Totem loves its Two-leggeds and will bring good luck, healing, balance, and a sense of inner joy. She can take our prayers to the Creator and intercede on our behalf. As with Eagle, Spirit Hummingbird teaches us to soul travel, and she is the best Totem to assist in developing abilities and learning to walk through the world in grace.

Mountain Goat

(Oreamnos americanus or pah-HA-ton-kah tah-TOH-kah-nah) is a fascinating Totem. He shows us how to walk surefooted through the trials of life. His appearance is also a sign that it's time to begin a new stage in your life. Mountain Goat Totem is a great teacher of survival techniques and overcoming the winter times of our lives. He makes us aware of our surroundings and helps us appreciate the beauty of nature. Mountain Goat Totem can also be a message bearer, and even break into dreams to bring spoken or non-verbal communication. If this happens to you, seek out a Native Medicine Person and get an interpretation of what happened. Do not fear, you'll be able to remember every detail.

Osprey or Fish Hawk

(Pandion haliaetus or ho-GON chon-SH'KAH) is a powerful Totem, devoted to its Two-leggeds. Both male and female care for the young in the nest, and this capacity extends into the spirit world. Osprey Totem can fly into the future and determine if something bad is about to happen, then offer information and protection. He communicates this by causing a sense of foreboding or unrest in his humans. Spirit Osprey also is the main Totem that protects Two-

leggeds when they travel on rivers or lakes. Of equal importance, Spirit Osprey has the ability to help you find your purpose in life.

Owl

(Otus asio or he-NAH-kah-gah) is an enigma as a Totem. Native Americans usually consider Owl Totem a messenger—and this may be good or not good, depending on the message. As a creature of the night, Spirit Owl will seek out Two-leggeds who are also night people. A kinship develops to the point that its human seems to blossom in the moonlight. Owl Totem offers wisdom, fertility, power, and knowledge, and helps men discover the feminine side of their persona.

Quail

(Gallifomes Lophortyx or she-YO-sha-peh-nah) is a positive totem that symbolizes friendship or companionship. Spirit quail reaches out to its human to assure he or she is never alone. Quail teaches Two-leggeds to be mindful of spiritual or emotional danger and how to escape it. As we become more tuned in to this marvelous creature, we find ourselves more able to respond quickly and successfully to crises in our lives.

Ram

(Ovis Canadensis or pah-HA-ton-kah TAH-cha-ska) is another interesting totem. When it enters a human's spirit world the ram is a precursor to renewal, new beginnings, and new life. It brings a sense of expectation and excitement that overflows into our lives. Our mental faculties and imagination are stimulated. Enjoy! Power and strength also accompany Ram Totem. His Two-leggeds will be able to put their thoughts into action and have the ability to push aside impediments.

Raven or Crow

(Corvus corax or kon-HE) is a splendid Totem because of his multiplicity. If a Two-legged is a hunter or fisherman, Raven Totem provides medicine and power for a successful outing. Some Native Americans associate Raven with good luck and impending wealth. Spirit Raven is strong against evil spirits and a great advocate in mystical conflict; therefore he provides his Two-leggeds with warrior medicine and protection as they fight the good fight of daily living.

The Tlingit Indians of the Alaskan panhandle divide humans into two groups: Eagles and Ravens. Raven-people are considered wise and adaptable. Some Medicine people say Raven is one of the few natural powers and supernatural aids that can cross into the land of the deceased and return with messages and words of hope.

Snake

(Ophidia squamata or zoo-ZOO-eh-cha) is a rare and unusual Totem, and few Two-leggeds walk in the spirit world with him. He aids in the development of psychic powers, brings hunting and fishing success, and is a strong fighter in spiritual conflict. Because many people fear and dislike snakes, we have a tendency to shy away from accepting a Snake Totem—and Snake is wary of becoming involved with the human spirit. If you find you have Snake as your Totem, consider this an exceptional opportunity. Spirit Snake can teach you how to interpret bad signs and symbolic communication, and then how to use good symbols and power from Nature to protect your loved ones and yourself.

Squirrel

(Scuridae or ze-CHA) is an enigma in some ways, because each squirrel is unique and independent. In fact, more than one squirrel totem may communicate different messages to the same person. In all cases, squirrel is positive, active, and energetic—a good example for people who seek balance in their lives. Listen carefully if one of your totems is spirit squirrel. He will help you find the answers to important questions: Am I too active or too sedentary? Am I too focused on collecting and accumulating? Do I work too much instead of having fun?

Turtle

(Clemmys guttata or pah-T'KAH-sha-nah) is a magnificent Totem, symbolic of all that's good in the world. Traditional Sioux Indians of north central North America believe pah-T'KAH-sha-nah protects newborn infants, so they put the baby's navel cord in a turtle amulet and hide it in the bedding. Spirit Turtle is a healer and protector who can lead his Two-leggeds into a long, productive life filled with wisdom and good health. Turtle was an important creature in uniting heaven and earth, and will share those attributes with its Two-legged as that person seeks out the Creator.

Whale or Orca

(Orcinus orca—not found in Dakotah nomenclature) is an unusual Totem, a sign of wealth and prosperity by coastal Indians. The Maori people of New Zealand believe Whale is the father of their civilization. Spirit Whale can forewarn his Two-leggeds when things are getting out of balance, or if something bad is about to happen. Whale is a primitive land mammal that returned to the sea, and therefore can help its human move through life changing events. If you're fortunate enough to have Whale as your Totem, know you are not alone and things will work out for the best.

Wolf

(Canis lupus or shoong-TOK-cha) is an amazing Totem: wise, cunning, and intelligent. Undoubtedly the strongest of all canines, a Wolf Totem is a great friend in the face of adversity. Wolves and Two-leggeds have shared a mysterious bond of brotherhood since the beginning of time. If you're blessed to have Wolf as your Totem, you can rely on his protection and courage. You can walk without fear in the corporal or mystical world, knowing the most powerful of Totems walks at your side.

Survey

Please read the following statements and decide to what extent you feel they are true of you and/or your life way: (Very Much—Somewhat—A Little—Not at All). Place the number value you think most closely applies in the space before each item.

Fox

Very Much = 3 points
Somewhat = 2 points
A Little = 1 point
Not at all = No points

_____1. Some people are uneasy in caves or caverns. When I visit them, I feel curious and comfortable.

_____2. People say I remind them of a grizzly bear when I'm angry or tackling a difficult project. They have a tendency to avoid me during those times.

_____3. Whenever I'm near a shallow brook, I want to wade in and build rock or log dams to deepen the water.

_____4. During stressful times I dream or daydream about flying away among the clouds.

_____5. Occasionally, I see buffalo meat or beefalo meat in the store. Even though it's supposed to be good for my health, I won't ever buy it.

_____6. I think cats are delightful, affectionate pets. They seem to take to me.

_____7. I appreciate that cats are strong, independent, and intelligent.

_____8. I've almost always had dogs as pets throughout my life. I have to admit we seem to have an unusual bond.

_____9. I love the fragrance a deer emits and can sense it, even when the animal isn't nearby.

_____10. During my vacations I gravitate to the ocean rather than the forest or mountains.

_____11. When I hear an eagle call or see it soaring on an up-draft, my heart and soul are touched. I long to fly with it.

_____12. I won't even consider going deer hunting and don't respect people who consider this a form of recreation.

_____13. Some people have likened me to a fox because they think I'm clever and quick to respond in potentially dangerous situations.

_____14. If I hear frogs singing during the summer nights it brings me a sense of comfort, peace, and oneness with my world.

_____15. It's important for me to return to the location I consider home whenever possible.

_____16. Over the years I have had different partners, but it has always been my predisposition to remain with one person – hopefully for life.

_____17. I enjoy sketching or painting different kinds of birds, and I'm attracted to bird art in museums and art galleries. I have bird-theme art works at home or at work.

_____18. I'm attracted to the mountains and the wild country and try to spend time in those settings.

_____19. I enjoy eating fish and seafood.

_____20. I'm comfortable in the dark and even prefer it to daylight.

_____21. I'm a nurturing person, especially protective toward children and those who are less fortunate then myself.

_____22. I was born under the sign of Aries (March 21 – April 19) and have Aries symbols in my life. Or, I'm not an Aries, but have a strong attraction for Aries people.

_____23. Some people are annoyed by the raucous call of crows and ravens. I enjoy the sound.

_____24. I feel angry when I hear about community snake-killing or snake-trappings outings. The creatures have as much right to live as we do.

_____25. I like to save money and store-up necessities in case lean times come along.

_____26. I would like to have, once had, or still have, a turtle shell rattle. I enjoyed shaking it and felt special power when I played it.

_____27. If you visit my home, you'll see pictures of whales and sea life. I love the sea theme and feel comfortable with it.

_____28. I have pictures of wolves on the walls of my home. I love their mysterious and independent life ways.

_____29. I never give up. When confronted with a big problem, I take it in my figurative teeth and shake until it surrenders.

_____30. When I go to the wild country, I hope to see bear. At the zoo, I find myself lingering in the bear exhibits.

_____31. People tell me I'm a hard worker and have an extra of capacity to get the job done.

_____32. I like to be around lakes and streams, but I prefer to wade rather than swim in the water.

_____33. Sometimes I have dreams or visions about wide open spaces where I'm roaming on a vast and treeless sunlit plain.

_____34. I find myself wanting to prowl around during the night. I'm just not tired, and it isn't necessarily a full moon time.

_____35. When I go to the zoo or to a wild life part, I'm mesmerized by the big cats and could watch them all day long.

_____36. Confession time: When I was young and used to watch Roadrunner cartoons, I found myself feeling sorry for Wylie Coyote.

_____37. When I see deer, I feel happy. I might even try to get closer to them and send mental messages of friendship.

_____38. I've had dreams or visions about dolphins or an unusual, yet real, experience with them.

_____39. I have eagle pictures on the walls of my home and eagle figurines on my shelves and bookcases. I enjoy wearing eagle theme jewelry, accessories or clothing – not necessarily Harley-Davidson stuff.

_____40. Seeing animals like elk or wapiti on TV or in the zoo intrigues me. I'm interested in learning more about them.

_____41. Snuggling down in a dry, warm burrow or den sounds pleasant to me. I might consider my house or apartment like a den.

_____42. Whenever possible, I avoid stressful or uncomfortable situations by jumping away from the setting and going for a walk or a drive.

_____43. I have dreams or visions that I'm soaring high above the earth for some purpose – by myself or with other creatures.

_____44. I love all kinds of hawks and have pictures and art images with hawk themes. I don't know why I prefer them over other birds, maybe I feel sense of kinship.

_____45. I feel a sense of joy when I see a hummingbird. I have a bird bath or hummingbird feeder and keep it cleaned and filled.

_____46. I don't necessarily seek high places, like tall buildings or bridges, but I'm comfortable in those situations.

_____47. I wish I could fly. I think I'd enjoy the view from the top of a tall tree or high rocky crag.

_____48. I don't know anyone personally who has "heard the owl call my name" (Native American death warning), but I believe it's possible.

_____49. When I'm almost asleep or in deep meditation, I have a sense that some special knowledge or under-standing is trying to connect with me.

_____50. I love the hills and mountains and find special beauty there. I naturally gravitate to that setting.

_____51. If I found a shiny black feather from a crow or raven, I would pick it up and save it.

_____52. Many people fear snakes. I am intrigued by them. I wouldn't mind having one for a pet – or I already do have a pet snake.

_____53. People say I'm industrious and hard working, but I also find time to have fun and socialize.

_____54. I've been healthy most of my life compared to others my age. Sometimes I feel a good spirit is watching over me.

_____55. When I get into the water, I enjoy it so much that I could remain there all day long. Sometimes I wish I had gills and fins.

_____56. I love dogs and they seem to take to me. I think humans and canines were ancient brothers, or pack members, in another time and place.

_____57. I enjoy working in a garden or flowerbed. I like The fragrance of the newly-turned earth and the treasures I find there.

_____58. I'm attracted to bear theme jewelry. If I could find a bear claw necklace – I would buy it.

_____59. Woe to the person who tries to threaten my friends or family. They will never forget my bite.

_____60. Whenever I am outdoors there always seem to be birds around. They don't appear to be afraid of me as they go about their business. Sometimes they come closer if I'm quiet.

_____61. I've been called bull headed when I stand-up for something I deeply believe in.

_____62. I know this sounds strange, but I've heard feral cats yowling in my dreams, and I found it exciting and familiar.

_____63. Cat images and artifacts are significant contributions to my home décor. I have a cat picture in almost every room.

_____64. I shouldn't admit this, but I sometimes enjoy fooling people and confusing them—but not in a harmful way.

_____65. I'm not a vegetarian, but the thought of eating venison is repulsive to me.

_____66. I enjoy wearing jewelry or accessories with a fish theme, or have a tattoo of a dolphin.

_____67. I know eagles and I are kindred spirits. On occasion I have bird dreams. In most cases the birds are eagles, or some other large raptor.

_____68. I have seen taxidermied deer heads in people's homes or in lodges and rustic inns. This sickens me, and I would like to "stuff" the person who did it.

_____69. Sometimes I have dog dreams. I see myself hunting for rabbits and other small creatures, but not in a pack of canines.

_____70. Even as a young child I would laugh when I saw pictures of frogs. I think they're humorous with their buggie eyes and simple facial expressions. I have frog theme art objects around my home.

_____71. For some unexplainable reason, I can sense before most people when the weather or seasons are starting to change.

_____72. I am experiencing (or have experienced) a deep personal awakening as if something coiled up inside (kundalini) is finally unraveling. Some of my childhood visions are coming to pass and being empowered and fulfilled.

_____73. People tell me I don't always stick to a single task until it's been completed. They say I have a tendency to flit from one activity to another.

_____74. Spirit mountain goats have come into my dreams or visions. I think they are bringing me messages or new knowledge.

_____75. I enjoy being on the water when I'm around lakes or rivers. I feel safe and comfortable there.

___76. I have owl theme artwork and figurines in my home. I love owls and admire their power and ability to survive. I look for them in the night.

___77. I feel more alive and tuned-in during spring and autumn than during winter and summer. I like to hunker down with friends and family for the cold months.

___78. People say they like me because of my curiosity and active imagination. Both have grown more noticeable over the years.

___79. I realize crows and ravens are among the most adaptable birds on the planet, found in the frozen north and on the burning desert. I sometimes put out food for them.

___80. I've been called a "snake in the grass" or similar epithet. It annoys my critics when I consider this a compliment.

___81. Yes, I am a tree hugger and I don't care what other people say about it. I think trees are sentient beings like us and should be appreciated and protected.

___82. I've always been interested in turtles. I once had a pet turtle I cared for.

___83. I get angry when I hear foreign countries like Japan and Russia indiscriminately kill whales and other sea mammals.

___84. I've had dreams or visions where large canine creatures wandered in and out of my consciousness, yet it was never a frightening experience. I'm a member of a pack.

___85. I've heard that people say I "badger" them until they accomplish a task or resolve a problem.

___86. Throughout my childhood, I had a favorite toy I preferred over any other. My favorite toy was a Teddy bear, or another stuffed bear.

___87. I've had dreams or visions of swimming in deep ponds or lakes with beaver or other aquatic mammals.

___88. People say I'm quick to perceive and take advantage of opportunities that come my way.

_____89. I admire the North American bison and deeply respect its adaptability. I'm glad it returned from near extinction in the 1890s.

_____90. When I visit people's homes and they have a pet cat, sooner or later the animal comes over to me and introduces itself.

_____91. When I am seeking sustenance, either at the grocery store or in the field, I usually find what I'm looking for with relative ease, compared to other people.

_____92. I love to hear Native American myths and legends about how Coyote participated in the creation of the world and the pranks he played on the Two-leggeds.

_____93. I've experienced mystical or unusual experiences involving deer.

_____94. I enjoy aquariums and find them beautiful and relaxing. I have one in my home, or wish I did.

_____95. I'm willing to travel long distances to see bald eagles in the wild. It thrills me to watch them catch fish and care for their young.

_____96. There's nothing like the sound of a bull elk whistling to his harem in the wild country. This marvelous sound stirs deep, yet familiar, feelings in my soul.

_____97. Dogs are far and away my favorite pet – especially smaller ones in the lap dog category.

_____98. I don't especially like hot, dry climates. I sunburn easily and need more lotion than most people. I prefer a cooler, moist climate like the Pacific Northwest or the Northeast.

_____99. Over the years, people have mentioned that I seem to prefer to settle-in and lay back. This could be a sign of my nesting proclivity.

_____100. People who know me say I readily perceive the nuances of an issue or situation. They appreciate my hawk-eyed abilities.

_____101. I occasionally have bird dreams or visions that are trying to bring me a message or new knowledge.

_____102. I have experienced "the winter of our discontent" and emerged better for it.

_____103. I collect feathers when I find them in my travels. I can't tell you why – I guess I like the feel and the colors.

_____104. The ancient Greeks worshipped Athena, the goddess of wisdom, and her symbol was the owl. I can easily relate to that.

_____105. I'm attracted to arid habitats. I like to walk among the trees and bushes and feel comfortable and protected.

_____106. Autumn is my favorite time of year. When the rest of the world seems to be winding down and preparing for winter, I'm motivated to assert my strength and take on new challenges.

_____107. I have pictures of ravens in my home and collect bird jewelry and accessories.

_____108. I've had dreams about snakes, and I find these dreams are captivating and comforting.

_____109. I enjoy watching squirrels forage for food. I even put out peanuts for them to find.

_____110. I love the beach and especially enjoy being covered with warm sand.

_____111. When I swim or snorkel in warm ocean water, I feel a sense that someone or something is caressing me.

_____112. I cannot understand why the U.S. Department of Interior encourages wolf eradication. There are no documented cases of humans being killed by wolves.

_____113. A look in my clothes closet will uncover more shirts, blouses, or sweaters with colorful contrasting stripes than most people own. I can't explain this, except I like the color scheme.

_____114. I've had dreams or visions that involved bear or bear artifacts. I think the *ursus* are trying to get in touch with me.

_____115. I'm nocturnal in nature and do my best work after the sun goes down.

_____116. I've always been intrigued by birds that thrive in a water environment. I try to find ways to be near them, I enjoy watching them provide for themselves and their families.

_____117. If I could afford it, I would live in northern climes in the summer and then migrate to warm weather in the winter.

_____118. Other people can tell I like felines, because of the cats on my clothing, jewelry, and accessories. I've considered a cat tattoo.

_____119. I feel a deep sense of spiritual protection around me. I do not fear negative powers or mystical forces.

_____120. I feel I am growing spiritually and the meaning of life is almost in my grasp. Something has been patiently leading me onward and upward.

_____121. Some of my most pleasant thoughts or day dreams involve the forest and its pristine environment. I sometimes feel I was an animal in a former life.

_____122. I love to swim and participate in water activities. People might describe me as a water creature living away from my natural environment.

_____123. I have had an out of body experience, also called soul Travel. I wasn't afraid and felt a companion with me.

_____124. On occasion I have had deer Dreams. When this occurs I experience a sense of comfort and feel like I belong to a family.

_____125. I have seen foxes, or enjoyed studying pictures of them. I feel the fox is the most beautiful canine on the planet.

_____126. It makes me feel sick to see frog legs for sale in ethnic food markets. They say, "It tastes just like chicken." So I reply, "Then let's just eat chicken."

_____127. Some people accuse me of being a potential vegetarian because I almost never eat meat and never touch the meat of chicken, turkey, or other birds.

_____128. I believe in protecting all forms of raptors and their habitat. I've considered joining a wildlife conservation group like the Sierra Club.

____129. I feel a sense of kinship when I see hummingbirds. I think they are marvelous creatures and members of my family.

____130. I think I am adroit and sure-footed as I step through potentially uncomfortable situations.

____131. It doesn't happen all the time, but I've déjà vu experiences or premonitions that later come true.

____132. Some people fear owls and think they're scary or creepy. I've never felt that way and am fascinated by owls.

____133. I never eat wild birds. I feel it's not for me, though I can't explain why.

____134. I love the feel of wool clothing and I appreciate the animals' willingness to share their fleece for my comfort.

____135. My animal dreams involve large, black, glossy birds. I think they're trying to bring me knowledge.

____136. I detest cold weather. I'd love to settle into a warm, cozy den for the entire winter.

____137. I've heard some people eat squirrels. Just the thought of eating a squirrel makes me ill.

____138. People say I'm insightful, thoughtful, and slow to anger.

____139. I am spiritually attracted to the ocean and especially enjoy quiet walks on the beach.

____140. When I hear wolves howling (either live or on TV), the sound of it stirs my soul.

____141. I have thought about, day-dreamed or actually dreamed about living in a home beneath the earth, like a Hobbit house.

____142. I'm crazy about all kinds of bears. When the sign says Don't Feed the Bears – I do it anyway.

____143. I would love to have a cabin on a lake or river.

____144. Sometimes I hear birds calling, but I can't always spot them. I occasionally wonder if it was a dream or reality.

____145. People say my life seems to be together. I have a smooth synchronicity and things seem to be on the right track.

_____146. I'm happiest by myself out in nature. Nature invigorates me and allows me to recharge my batteries. I can be alone and not be lonely.

_____147. I feel a sense of welcome around the cat family – large cats or house cats. I think I can find past life connections by determining the type of cat I most identify with.

_____148. I enjoy garage sales, flea markets, and antique stores. I don't necessarily buy anything, but the search is as much fun as the prize. Maybe I'm a scavenger at heart.

_____149. I'm more content in a group than by myself. I have learned many types of deer migrate with the seasons, seeking an easier habitat during the winter months. I want to be like that.

_____150. I strongly disagree with the U.S. Navy doing experiments with dolphins. I've heard they're training them to carry explosives and underwater video devices.

_____151. People say I have a special ability to see things others miss. Sometimes I find the deeper meaning of someone's actions or words – at other times, I find lost items.

_____152. I especially like to be out in nature during autumn. Even though the Earth is preparing for a long winter's nap, I feel charged and energetic.

_____153. I like to be in locations or situations where I blend in and become almost invisible. This gives me a good perspective on other people and what's happening.

_____154. I have a good ear for music. I'm sensitive to the power of sound and can distinguish quality from noise.

_____155. The idea of migrating appeals to me. I get restless to travel in the spring and fall.

_____156. I love the open spaces. I would never be totally happy living in the city.

_____157. Hummingbirds lighten my spirit.

_____158. I admire the way mountain goats thrive in a harsh habitat. I'd like to develop those traits to improve my situation in life.

_____159. I have a tendency to make a nest for myself and my loved ones. It makes me happy to provide for them and know they're safe.

_____160. I like to go for walks after dark. I feel comfortable in the darkness.

_____161. I love birds. I keep bird feeders and bird baths and they're always clean and filled.

_____162. Lately, I've felt a streak of creativity. I am cooking different dishes or having bright ideas for work or home projects.

_____163. When I watch a flock of crows or ravens flying across the sky, I get the feeling they're my brothers and sisters and I'd like to be soaring with them. I envy their freedom.

_____164. I have an inner drive to change my life on a regular basis. I know I should settle down and ride things out, but I just don't want to do it.

_____165. If you come to my house for a visit, you'll nibble on nuts, crackers and other healthy snacks rather than sweets.

_____166. I believe the Turtle Totem reaches for its human with an open heart. It can bring discernment, vision, and discrimination into my life.

_____167. I have always been especially aware of sounds. Sometimes I can hear a gentle heartbeat—not my own.

_____168. People have said I'm truly a free spirit and spending time with me is refreshing and invigorating.

_____169. I like to create stories and tales about animal families and their adventures. I'm considering writing a book – or have already written a book.

_____170. The phases of the moon affect me. During the full moon, I lie awake at night or even to prowl around the house.

_____171. I've always been intrigued by the Masonic Order or the Eastern Star organizations. I either wish I knew how to build things, or I've worked in home construction or the building trades.

_____172. I believe we have a responsibility to help our bird brothers and sisters survive.

_____173. I like to be surrounded by family and friends. I don't like being alone for extended periods.

_____174. In a family or group setting, I'm careful about what I share with others. I enjoy companionship, but I am cautious about when to speak, how much to say, and to whom.

_____175. My friends call me a cat person. They seem surprised when their house cats, usually aloof and wary, warm up to me.

_____176. If I had my choice of pets, I'd be happiest rescuing a mutt from the pound. When I look at my heritage – I might be considered a mutt myself.

_____177. People notice I'm protective and nurturing toward my family, especially my children.

_____178. I believe dolphins are important members of the mammal family. They are an ancient connection between water and earth – they live in the ocean, but breathe, give live birth, and communicate with each other like humans.

_____179. Sometimes I feel like an eagle. When I'm bored or in an uncomfortable situation, I take flight in my mind and find my happy place. I'm of the Earth, but not always in it.

_____180. People often encourage me to join teams, social clubs or congregations. They say I'm a positive asset to any group.

_____181. It is easy for me to believe that I was a canine in a past life. Canines are an important part of my existence as a Two-legged.

_____182. I'd love to spend the winter holed up somewhere warm and cozy. I don't like cold and snow.

_____183. I love and appreciate the beauty of large migrating waterfowl. I could never be a bird hunter.

____184. I have a special affection for our feathered friends. They are an interesting, beautiful, and important part of the Circle of Life.

____185. When I notice a weed-infested garden or tract of unkempt property, I want to clean it up and make it productive.

____186. Friends seem to think I can tackle just about anything set before me. They accuse me of having an iron constitution.

____187. I've always had a special affection for raptors (birds of prey). I feel angry when I find out somebody has thoughtlessly killed an eagle or a hawk.

____188. When dreaming or in deep meditation, I occasionally have an owl visitation. This comforts me and lets me know I have a friend in the spirit world.

____189. Friends and family enjoy coming to my house for meals. They feel I take an extra effort to make them feel comfortable and welcome.

____190. I'm attracted to the Dodge Ram and its Hemi engine.

____191. I can adapt to almost any situation. It isn't important to me where I am – I just want to be happy.

____192. I would be honored to be considered a snake person. I believe they possess great power for healing, creativity, and wisdom.

____193. Some of my dreams are busy and noisy—even exhausting. Something is trying to tell me "Wake up and smell the roses."

____194. When I go to an aquarium, a city park with a pond, or visit a Caribbean island—I look for turtles. When I find turtles, I watch them and try to communicate.

____195. When near the ocean, I might see whales spouting in the distance. This makes me want to get in a boat and travel alongside them.

____196. I love the wild country—especially at night. I'm not fearful at all and want to run and jump until I fall down in the tall grasses.

Deer

Scoring Your Survey

Now it's time to glean information from the survey you just completed. Each totem animal listed on the next pages is followed by numbers corresponding to the survey statements you completed.

First Example: Let's say you placed the value 3 before item 1 in the survey. This indicates the statement applies Very Much.

(3)_1. Some people are uneasy in caves and caverns. When I visit them, I feel curious and comfortable.

Second Example: Let's say you place the value 1 before item 142 in the survey, to indicate the statement applies A Little.

(1)142. I'm crazy about all kinds of bears. When the sign says Don't Feed the Bears, I do it anyway.

Beside each number below, place the value you gave that statement in the survey, ranging from no points to 3 points. Continue until you've entered all values. Then enter the total number of points at the end of each row.

Badger:
1.____ 29.____ 57.____ 85.____ 113.____ 141.____ 169.____ Total:____

Bear:
2.____ 30.____ 58.____ 86.____ 114.____ 142.____ 170.____ Total:____

Beaver:
3.____ 31.____ 59.____ 87.____ 115.____ 143.____ 171.____ Total:____

Blue Heron:
4.____ 32.____ 60.____ 88.____ 116.____ 144.____ 172.____ Total:____

Buffalo:
5.____ 33.____ 61.____ 89.____ 117.____ 145.____ 173.____ Total:____

Bobcat:
6.____ 34.____ 62.____ 90.____ 118.____ 146.____ 174.____ Total:____

Cougar:
7.____ 35.____ 63.____ 91.____ 119.____ 147.____ 175.____ Total:____

Coyote:
8.____ 36.____ 64.____ 92.____ 120.____ 148.____ 176.____ Total:____

Deer:
9.____ 37.____ 65.____ 93.____ 121.____ 149.____ 177.____ Total:____

Dolphin:
10.____38.____ 66.____ 94.____ 122.____ 150.____ 178.____ Total:____

Eagle:
11.____39.____ 67.____ 95.____ 123.____ 151.____ 179.____ Total:____

Elk:
12.____40.____ 68.____ 96.____ 124.____ 152.____ 180.____ Total:____

Fox:
13.____41.____ 69.____ 97.____ 125.____ 153.____ 181.____ Total:____

Frog:
14.____42.____ 70.____ 98.____ 126.____ 154.____ 182.____ Total:____

Canada Goose:
15.____43.____ 71.____ 99.____ 127.____ 155.____ 183.____ Total:____

Hawk:
16.____44.____ 72.____ 100.____ 128.____ 156.____ 184.____ Total:____

Hummingbird:
17.____45.____ 73.____ 101.____ 129.____ 157.____ 185.____ Total:____

Mountain Goat:
18.____46.____ 74.____ 102.____ 130.____ 158.____ 186.____ Total:____

Osprey:
19.____47.____ 75.____ 103.____ 131.____ 159.____ 187.____ Total:____

Owl:
20.____48.____ 76.____ 104.____ 132.____ 160.____ 188.____ Total:____

Quail:
21.____49.____ 77.____ 105.____ 133.____ 161.____ 189.____ Total:____

Ram:
22.____50.____ 78.____ 106.____ 134.____ 162.____ 190.____ Total:____

Raven:
23.____51.____ 79.____ 107.____ 135.____ 163.____ 191.____ Total:____

Snake:
24.____52.____ 80.____ 108.____ 136.____ 164.____ 192.____ Total:____

Squirrel:
25.____53.____ 81.____ 109.____ 137.____ 165.____ 163.____ Total:____

Turtle:
26.____54.____ 82.____ 110.____ 138.____ 166.____ 194.____ Total:____

Whale:
27.____55.____ 83.____ 111.____ 139.____ 167.____ 195.____ Total:____

Wolf:
28.____56.____ 84.____ 112.____ 140.____ 168.____ 196.____ Total:____

Summary Page

Compare your score totals above. Pick your five highest scores, then list these five Totems or Spirit Animals below. Do you see any a trend or hear a specific voice calling to you?

Some people who study Totems say a person may have as many as seven Spirit Animals (one for each of the sacred directions: North—East—South—West—Above—Below—and Within) waiting to help. This conjures up a vivid picture of what may be happening in your spirit world: A menagerie of helpers at the ready. All you need to do is call.

	Totem or Spirit Animal	Total Score
1.	_____	_____
2.	_____	_____
3.	_____	_____
4.	_____	_____
5.	_____	_____

Ask friends or family member to take the survey, then compare your results. As you discuss each other's lists, share stories about your favorite animals. Now that you know which Spirit Animals may be trying to communicate with you, think of ways you can open up your heart, mind, and spirit to their call.

Catfish

Totem Indicators—Synopsis

Badger

1. *Environmental Preference* - Some people are uneasy in caves and/or caverns. When I visit them, I'm always curious and comfortable.

29. *Personal Characteristics* - Frankly, I never give up. If I am confronted with a big problem, I take it in my figurative teeth and shake until it surrenders.

57. *Personal Preference* - I enjoy working in a garden or flowerbed. I like the fragrance of the newly- turned earth and the treasures I find there.

85. *Other's Perceptions* - I've heard people say I badger them until they accomplish a task or resolve a problem.

113. *Personal Preference* - A look in my clothes closet will display more shirts, blouses, or sweaters with colorful contrasting stripes than most people have. I can't explain this, except I like the color scheme.

141. *Supernatural Communication* - I have thought about, day-dreamed or actually dreamed about living in the earth or in a Hobbit hole.

169. *Familial Bonding* – I like to create stories about animal families and their adventures.I'm considering writing a book – or have already written a book.

Bear

2. *Other's Perceptions* - People say I remind them of a grizzly bear when I'm angry or tackling a difficult project. They have a tendency to avoid me at such times.

30. *Environmental Preference* - When I go to the wild country I hope I will see bear. At the zoo, I linger in the bear exhibit.

58. *Personal Preference* - I'm attracted to bear theme jewelry. If I could find a bear claw necklace, I would buy it.

86. *Personal Preference* - Throughout my childhood, I had a favorite toy I preferred over any other. My favorite toy was a Teddy bear, or another stuffed bear.

114. *Supernatural Communication* - I have had dreams or visions that involved bear or bear artifacts. I think the *ursus* are trying to get in touch with me.

142. *Affinity Toward Animal* - I'm crazy about all kinds of bears. When the sign says Don't Feed the Bears – I do it any way. I'd like to belong to a wildlife preservation association.

170. *Personal Characteristics* - I seem to be affected by the phases of the moon. During the full moon I have a tendency to lie awake at night or prowl around the house.

Beaver

3. *Environmental Preference* - When I'm near a shallow brook I want to wade in and build rock or log dams to deepen the water.

31. *Other's Perception* - People tell me I'm a hard worker and have an extra capacity to get the job done.

59. *Personal Characteristics* - Woe to the person who tries to threaten my friends or family. They will never forget my bite.

87. *Supernatural Communication* - I've had dreams or visions of swimming in deep ponds or lakes with beaver or other aquatic mammals.

115. *Personal Characteristics* - I'm nocturnal by nature and do my best work after the sun goes down.

143. *Personal Preference* - I would love to have a cabin on a lake or river.

171. Familial Bonding - I've always been intrigued by the Masonic Order or the Eastern Star organization. I either wish I knew how to build things, or I've worked in home construction or the building trades.

Blue Heron

4. *Personal Characteristics* - During stressful times I dream or daydream about flying in the clouds.

32. *Environmental Preference* - I like to be around lakes and streams, but I prefer to wade rather than swim in the water.

60. *Familial Bonding* - Whenever I am outdoors there always seem to be birds around. They don't appear to be afraid of me as they go about their business. Sometimes they come close to me if I'm quiet.

88. *Other's Perceptions* - Other people say I'm quick to perceive and take advantage of opportunities.

116. *Personal Preference* – I've always been intrigued by birds that thrive in a water environment. I try to find ways to be where they are and enjoy watching them provide for themselves and their families.

144. *Supernatural Communication* - Sometimes I hear birds calling, but I can't always spy them. I occasionally wonder if it was a dream or reality.

172. *Affinity Toward Animal* - Some people may consider me a bird hugger, but I don't mind. I believe it's our responsibility to help our bird brothers survive.

Buffalo

5. *Personal Preference* - Occasionally, I see buffalo meat or beefalo meat in the store. Even though it's supposed to be good for my health, I would never buy it.

33. *Supernatural Communication* - Occasionally I have dreams or visions about wide open spaces where I'm roaming on a vast and treeless sunlit plain.

61. *Personal Characteristics* - I've been called bull headed when I stand-up for something I deeply believe in.

89. *Affinity Toward Animal* - I admire the North American bison and deeply respect its adaptability. I'm glad it returned from near extinction in the 1890s.

117. *Environmental Preference* - If I could afford it, I would live in the northern climes in the summer and migrate to warm weather in the wintertime.

145. *Other's Perceptions* - People who know me say my life seems to be together. I possess a sense of synchronicity and things seem to be on the right track.

173. *Familial Bonding* - I like to be surrounded by family and friends. I don't like being alone for extended periods.

Bobcat

6. *Affinity Toward Animal* - I think cats are affectionate and cuddly pets in many ways. They seem to take to me also.

34. *Personal Characteristics* - I find myself wanting to prowl around during the night at times. I'm just not tired – and it isn't full moon time necessarily.

62. *Supernatural Communication* - I've heard feral cats yowling in my dreams, and I found it exciting and familiar.

90. *Other's Perception* - When I visit people's homes and they have a pet cat, sooner or later the animal comes over to me and introduces itself.

118. *Personal Preference* - People can tell I like felines because of the cats on my clothing, jewelry, and accessories. I may even have a cat tattoo.

146. *Environmental Preference* - I'm happiest by myself out in nature. Nature invigorates me and allows me to recharge my batteries. I can be alone and not be lonely.

174. *Familial Bonding* - In a family or group setting, I'm careful about what I share with others. I enjoy companionship, but I am cautious about when to speak, how much to say, and to whom.

Cougar

7. *Affinity Toward Animal* - I appreciate that cats are strong, independent, and intelligent.

35. *Environmental Preference* - When I go to the zoo or to a wildlife park, I'm mesmerized by the big cats and could watch them all day long.

63. *Personal Preference* - Cat images and artifacts are significant contributions to my home décor. I have a cat picture in almost every room.

91. *Personal Characteristics* - When I'm seeking sustenance, either at the grocery story or in the field, I usually find what I am looking for with relative ease, compared to other people.

119. *Supernatural Communication* - For some unexplainable reason, I feel a deep sense of spiritual protection and do not fear negative powers or mystical forces.

147. *Familial Bonding* - I feel a sense of welcoming around the cat family – large cats or house cats. I think I can find past life connections by determining the type of cat I most identify with.

175. *Other's Perceptions* - My friends call me a cat person. They seem surprised when their house cats, usually aloof and wary, warm up to me.

Coyote

8. *Familial Bonding* - I've almost always had dogs as pets throughout my life. We seem to have an unusual bond.

36. *Affinity Toward Animal* - Confession time: When I was young and used to watch Roadrunner cartoons, I felt sorry for Wylie Coyote.

64. *Personal Characteristics* - I probably shouldn't admit this, but I sometimes enjoy fooling people and confusing them, although not in a hurtful way.

92. *Other's Perceptions* - I love to hear Native American myths and legends about Coyote's participation in the creation of the world and the pranks he played on Two-leggeds.

120. *Supernatural Communication* - I feel I am growing spiritually and the meaning of life is almost in my grasp. Something has been patiently leading me onward and upward.

148. *Environmental Preference* - I enjoy garage sales, flea markets, and antique stores. I don't necessarily buy anything, but the search is as much fun as the prize. Maybe I'm a scavenger at heart.

176. *Personal Preferences* - If I had my choice of pets, I would be happiest rescuing a mutt from the pound. When I look at my heritage – I might be considered a mutt myself.

Deer

9. *Personal Preference* - I love the fragrance a deer emits and can sense it even if the animal isn't nearby.

37. *Personal Characteristics* - When I see deer it makes me feel happy. I might even try to get closer to them and send them mental messages of friendship.

65. *Affinity Toward Animal* - I am not a vegetarian, but the thought of eating venison is repugnant to me.

93. *Supernatural Communication* - I have had mystical or unusual experiences involving deer.

121. *Environmental Preference* - Some of my most pleasant thoughts or daydreams involve the forest and its pristine environment. I sometimes feel I was an animal in a former life.

149. *Familial Bonding* - I am more content in a group than by myself. I've learned that many types of deer migrate with the seasons, seeking an easier habitat during the winter months. I want to be like that.

177. *Other's Perceptions* - People notice I'm protective and nurturing toward my family, especially my children.

Dolphin

10. *Environmental Preference* - When I take vacation time, I gravitate to the ocean rather than the forest or mountains.

38. *Supernatural Communication* – I've had dreams or visions about dolphins, or unusual, yet real, experiences with them.

66. *Personal Preference* – I enjoy wearing jewelry or accessories with a fish theme. I have a tattoo of a dolphin, or would like to have one.

94. *Personal Preference* - I enjoy aquariums and find them beautiful and relaxing. I have one in my home, or wish I did.

122. *Personal Characteristics* - I love to swim and participate in water activities. People might describe me as a water creature living away from my most natural environment.

150. *Affinity Toward Animal* - I strongly disagree with the U.S. Navy's experiments with dolphins. I've heard they're training them to carry explosives and underwater video devices.

178. *Familial Bonding* - I believe dolphins are important members of the mammal family. They are an ancient connection between water and earth – they live in the ocean, but breathe, give live birth, and communicate with each other – just as humans do.

Eagle

11. *Affinity Toward Animal* - When I hear an eagle call or see it soaring on an up-draft, my heart and soul are touched. I long to fly with it.

39. *Personal Preference* - I have eagle pictures on the walls of my home and eagle figurines on my shelves and bookcases. I enjoy wearing eagle-theme jewelry, accessories, and clothing – not necessarily Harley-Davidson stuff.

67. *Familial Bonding* - I am confident eagles and I are kindred spirits. On occasion I have bird dreams. In most cases, the birds are eagles or some other large raptor.

95. *Environmental Preference* - I am willing to travel long distances to see bald eagles in the wild. It thrills me to watch them catch fish and care for their young.

123. *Supernatural Communication* - I have had an out of body experience, also called soul travel. Despite this strange event I was not afraid and felt a companion with me.

151. *Other's Perceptions* - People have said I have a special ability to see things others miss. This might be a deeper meaning to someone's actions or words, or I can find lost items.

179. *Personal Characteristics* - Sometimes I feel like an eagle. When bored or in an uncomfortable situation, I can take wing in my mind and find my happy place. I am of the Earth, but not always in it.

Elk

12. *Personal Preference* - I can't bear to even think about deer hunting and I don't respect people who consider this a form of recreation.

40. *Personal Characteristics* - Seeing animals like elk or wapiti on TV or in the zoo intrigues me. I'm interested in learning more about them.

68. *Affinity Toward Animal* - I have seen, or have seen pictures of, taxidermied deer heads on the walls of lodges and rustic inns. This sickens me, and I would like to "stuff" the person who did it.

96. *Supernatural Communication* – There's nothing like the sound of a bull elk whistling to his harem in the wild country. This marvelous sound stirs deep and familiar feelings in my soul.

124. *Familial Bonding* - On occasion I've had deer dreams. When this occurs I experience a sense of comfort and feel I belong to a family.

152. *Environmental Preference* - I especially like to be out in nature during autumn. Even though the Earth is preparing for its long winter's nap, I feel charged and energetic.

180. *Other's Perceptions* - People have encouraged me to join teams, social clubs, or congregations. They feel I'm a positive asset to any group.

Fox

13. *Other's Perception* - Some people have likened me to a fox because they think I'm clever and quick to respond in potentially dangerous situations.

41. *Personal Characteristics* - Snuggling down in a dry, warm burrow or den sounds pleasant to me. I might consider my house or apartment like this.

69. *Supernatural Communication* - Sometimes I have dog dreams. I see myself hunting for rabbits and other small creatures, but not in a pack of canines.

97. *Personal Preference* - Dogs are far and away my favorite pet – especially smaller ones in the lap dog category.

125. *Affinity Toward Animal* - I believe the red fox is the most beautiful canine on the planet.

153. *Environmental Preference* - I like to be in locations or situations where I blend in and almost become invisible. It gives me a good perspective on other people and what's happening.

181. *Familial Bonding* - It is easy for me to believe I was a canine in a past life. Canines are an important part of my existence as a Two-legged.

Frog

14. *Supernatural Communication* - When I hear frogs singing during summer nights it brings a sense of comfort, peace, and oneness with my world.

42. *Personal Characteristics* - Whenever possible I avoid stressful or uncomfortable situations by jumping away from the setting and going for a walk or a drive.

70. *Personal Preference* - Even as a young child I would laugh when I saw pictures of frogs. I think they're humorous with their buggie eyes and simple facial expressions. I have frog-theme art objects around my home.

98 *Environmental Preference* - I don't especially like hot, dry climates. I sunburn easily and need more lotion than most people. My preference would be a cooler, moist venue like the Northwest or Northeast.

126. *Affinity Toward Animal* - It makes me feel sick to see frog legs for sale in ethnic food markets. They say, "It tastes just like chicken." So I reply, "Then let's just eat chicken."

154. *Other's Perceptions* - My friends and acquaintances mention I seem to have a good ear for music. I'm sensitive to the power of sound and can distinguish quality from noise.

182. *Personal Preference* - I'd love to spend the winter holed up somewhere warm and cozy. I don't like cold and snow.

Canada Goose

15. *Environmental Preference* - It's important for me to return to the location I consider home whenever possible.

43. *Supernatural Communication* - I have dreams or visions of soaring high above the earth – by myself or with other creatures.

71. *Personal Characteristics* - I can sense before most people when the weather or seasons are starting to change.

99. *Other's Perceptions* - Over the years, people have mentioned I like to settle-in and lay back. This could be a sign of my nesting proclivity.

127. *Personal Preference* - Some people accuse me of being a potential vegetarian because I almost never eat red meat and never eat chicken, turkey, or other fowl.

155. *Environmental Preference* - If I could afford it, I would live in the northern climes in the summer and migrate to warm weather in the winter.

183. *Affinity Toward Animal* - I love and appreciate the
 beauty of large migrating waterfowl. I could never be a
 bird hunter.

Hawk

16. *Personal Characteristics* - Over the years I've
 had different partners; but it has always been my
 predisposition to remain with one person – hopefully for
 life.

44. *Personal Preference* - I love all kinds of hawks and have
 pictures and art images with hawk themes around my
 house or office.

72. *Supernatural Communication* - I am experiencing
 (or have experienced) a deep personal awakening,
 as if something coiled up inside (kundalini) is finally
 unraveling. Some of my childhood visions are coming to
 pass and being empowered and fulfilled.

100. *Other's Perceptions* - People who know me say I can
 perceive the nuances of an issue or situation. They
 appreciate my hawk eye abilities.

128. *Affinity Toward Animal* - I am a strong proponent of
 protecting all forms of raptors and their habitat. I may
 even be a member of a wildlife conservation group like
 the Sierra Club.

156. *Environmental Preference* - I love the open spaces.
 I would never be totally happy living in a large
 metropolitan area.

184. *Familial Bonding* - I have a special affection for our
 feathered friends. I find them an interesting, beautiful,
 and important part of the Circle of Life.

Hummingbird

17. *Personal Preference* - I especially enjoy sketching or
 painting different kinds of birds and I'm attracted to bird
 art in museums and art galleries. I have bird theme art
 work at home or at work.

45. *Affinity Toward Animal* - I feel a sense of joy when I see a
 hummingbird. I have a birdbath or hummingbird feeder
 and keep it cleaned and filled.

73. *Other's Perceptions* - People tell me I don't always stick to a single task until it has been completed. I have a tendency to flit from one activity to another.

101. *Supernatural Communication* - I occasionally have bird dreams or visions. I think they are trying to bring me a message or new knowledge.

129. *Familial Bonding* - I feel a sense of kinship when I see hummingbirds. I think they are marvelous creatures and members of my family.

157. *Personal Characteristics* - Hummingbirds lighten my spirit.

185. Environmental Preference - When I notice a weed-infested garden or tract of unkempt property, I want to clean it up and make it productive.

Mountain Goat

18. *Environmental Preference* - I'm attracted to the mountains and the wild country and try to spend time in those settings.

46. *Personal Preference* - I don't necessarily seek high places like tall buildings or bridges, but I don't feel uncomfortable in those situations.

74. *Supernatural Communication* - Spirit mountain goats have come into my dreams or visions. I think they're bringing me messages or new knowledge.

102. *Personal Characteristics* - I have experienced "the winter of our discontent" and emerged better for it.

130. *Personal Characteristics* - I feel adroit and sure-footed as I step through potentially uncomfortable situations.

158. *Familial Bonding* - I admire the way mountain goats thrive in a harsh habitat. I hope I can develop those traits to improve my situation in life.

186. *Other's Perceptions* - Friends seem to think I can eat just about anything set before me. They accuse me of having an iron disposition.

Osprey

19. *Personal Preference* - When I think about the eating preferences of my friends and family, I find myself ordering fish or seafood more than the others.

47. *Personal Preference* - I wish I could fly. I think I'd enjoy the view from the top of a tall tree or a high, rocky crag.

75. *Environmental Preference* - I enjoy being on the water when I'm around lakes or rivers. I feel safe and comfortable there.

103. *Personal Characteristics* - I collect feathers when I find them in my travels. I can't tell you why, but I like the feel and the colors.

131. *Supernatural Communication* - It doesn't happen all the time, but I've had déjà vu experiences or premonitions that later come true.

159. *Familial Bonding* - I have a tendency to want to make a nest for myself and my loved ones. It makes me happy to provide for them and know they're safe.

187. *Affinity Toward Animal* - I've always had a special affection for raptor-type birds. It makes me angry when I find someone has thoughtlessly killed an eagle or a hawk.

Owl

20. *Personal Characteristics* – I'm comfortable in the dark and might even say I prefer it to daylight.

48. *Affinity Toward Animal* - I don't know anyone personally who has "heard the owl call my name " (Native American death warning), but I believe it's possible.

76 *Personal Preference* - I have owl-theme artwork and figurines in my home. I love owls and admire their power and survivability. I look for them in the night.

104. *Other's Perceptions* - The ancient Greeks worshipped Athena, the deity of wisdom, and her symbol was the owl. I can easily relate to that.

132. *Familial Bonding* - Some people fear owls and think they're scary or creepy. I've never felt that way and am fascinated by owls.

160. *Personal Characteristics* - I'm nocturnal in nature and do my best work after the sun goes down.

188. *Supernatural Communication* - When dreaming or in deep meditation I occasionally experience an owl visitation. This comforts me and lets me know I have a friend in the spirit world.

Quail

21. *Personal Characteristics* - I seem to fit the role of a nurturer and feel especially protective toward children and disenfranchised people.

49. *Supernatural Communication* - When I'm almost asleep or in deep meditation, I feel some special knowledge or understanding is trying to connect with me.

77. *Personal Preferences* – During the yearly seasonal cycle, I seem more alive and tuned-in during spring and autumn. I like to hunker down with friends and family during the cold months.

105. *Environmental Preference* – I'm attracted to habitats that are more arid than not. I like to walk among the trees and bushes, where I feel comfortable and protected.

133. *Familial Bonding* - I never eat wild birds. I feel somehow that just isn't for me, although I can't explain why.

161. *Affinity Toward Animal* - I could be described as a crazy bird person. I have bird feeders and birdbaths and I keep them clean and filled.

189. *Other's Perceptions* - Friends and family say they enjoy coming to my house for meals. They feel I take extra effort to make them comfortable and welcome.

Ram or Big Horn Sheep

22. *Personal Preferences* - I was born under the horoscope sign of Aries (March 21 – April 19) and have Aries symbols in my life. Or, I may not be an Aries, but feel a strong attraction to Aries people.

50. *Environmental Preference* - I love the hills and mountains and find special beauty there. I naturally gravitate to that setting.

78. *Other's Perceptions* - People say they like me because of my curiosity and active imagination. They comment that both have grown more noticeable over the years.

106. *Personal Characteristics* - My favorite time of year is autumn. When the rest of the world is winding down and preparing for winter's chill, I'm motivated to assert my strength and move to new challenges.

134. *Affinity Toward Animal* - I love to snuggle in wool clothing and appreciate the animals' willingness to share their fleece for my comfort.

162. *Supernatural Communication* - Lately, I've felt a streak of creativity. I'm cooking different dishes or having bright ideas for work or home projects.

190. *Familial Bonding* - I'm attracted to the Dodge Ram and its Hemi engine.

Raven

23. *Personal Preference* - Some people are annoyed by the raucous calls of crows and ravens. I'm intrigued by the sound.

51. *Personal Preference* - If I found a shiny black feather from a crow or raven, I would pick it up and save it.

79. *Affinity Toward Animal* - I realize crows and ravens are among the most adaptable birds on the planet, found in the frozen north and on the burning desert. I sometimes put out food for them.

107. *Other's Perceptions* - I have pictures of ravens in my home and wear bird jewelry or accessories.

135. *Supernatural Communication* - My animal dreams involve large black, glossy birds. I think they're trying to communicate with me and bring new knowledge.

163. *Familial Bonding* - When I watch a flock of crows or ravens flying across the sky, I feel they're my brothers and sisters and I'd like to be soaring with them. I envy their freedom.

191. *Environmental Preference* - I am one of those people who can adapt to almost any situation. It doesn't matter where I am – I just want to be happy.

Snake

24. *Affinity Toward Animal* - It makes me angry when I hear about community snake-killing or snake-trapping outings. The creatures have as much right to live as we do.

52. *Personal Preference* - Many people fear snakes. I am intrigued by them. I wouldn't mind having one for a pet – or I already do have a pet snake.

80. *Other's Perceptions* - I've been called a snake in the grass or a similar epithet. It annoys my critics when I consider this a compliment.

108. *Supernatural Communication* - I have dreamt about snakes. This didn't bother me at all. I found it captivating and comforting.

136. *Environmental Preference* - I detest cold weather. I wish I were in a situation where I could settle in a nice warm cozy den for the entire winter.

164. *Personal Characteristics* - I find my life a paradox. There seems to be some inner drive to want to change my path on a regular basis. I know I should settle down and ride things out, but I just don't want to.

192. *Familial Bonding* – I'd be honored to be considered a snake person. I believe they possess great power for healing, creativity, and wisdom. I would feel a sense of rebirth in many ways.

Squirrel

25. *Personal Characteristics* - I save money and store-up necessities in case lean times come.

53. *Other's Perceptions* - People say I'm industrious and hard working, but I also find time for fun and socializing.

81. *Environmental Preference* - Yes, I am a tree hugger and I don't care what people say about that. I think trees are sentient beings like us and should be appreciated and protected.

109. *Familial Bonding* - I enjoy watching squirrels forage for food. I put out peanuts for them and think they're cute with their little hands and bright black eyes.

137. *Affinity Toward Animal* - I've heard people sometimes eat squirrels. Just the thought of eating a squirrel makes me ill.

165. *Personal Preferences* - If you come to my house for a visit you'll nibble on nuts, crackers, and other healthy snacks rather than sweets.

193. *Supernatural Communication* - Some of my dreams are busy and noisy – even exhausting. Something is trying to tell me to "wake up and smell the roses."

Turtle

26. *Supernatural Communication* - I would like to have a turtleshell rattle. I enjoyed shaking it and felt special power when I played it.

54. *Personal Characteristics* – I've been healthy most of my life compared to others my age. Sometimes I feel a good spirit is watching over me.

82. *Affinity Toward Animal* – I've always been interested in turtles. I had a pet turtle I cared for.

110. *Environmental Preference* - I love the beach and especially enjoy being covered with warm sand.

138. *Other's Perceptions* - People say I'm insightful, thoughtful before making a decision, and slow to anger.

166. *Familial Bonding* - I believe the Turtle Totem reaches for its human with an open heart. It can bring stronger discernment, vision, and discrimination into my life.

194. *Personal Preference* - When I go to an aquarium, a city park with a pond, or visit a Caribbean island – I look for turtles. If I find them I watch them and try to talk to them.

Whale

27. *Personal Preference* - If you visit my home, you'll notice pictures of whales and sea life on my walls and furniture. I love the sea theme and feel comfortable with it.

55. *Environmental Preference* - When I get into a swimming pool, a lake, or the ocean, I enjoy it so much I could stay all day. Sometimes I wish I had gills and fins.

83. *Affinity Toward Animal* - It makes me angry when I hear about foreign countries like Japan and Russia indiscriminately killing whales and other sea mammals.

111. *Supernatural Communication* - This may sound strange, but when I swim or snorkel in warm ocean water, I feel someone or something is caressing me.

139. *Supernatural Communication* - I am deeply and spiritually attracted to the ocean and especially enjoy quiet, contemplative walks on the beach.

167. *Personal Characteristics* – I've always been especially receptive toward sounds in and around me. Sometimes I can hear a gentle heartbeat – not my own.

195. *Familial Bonding* - When I am by the ocean, I might see whales spouting in the distance. This thrills me and makes me want to get in a boat and travel with them.

Wolf

28. *Personal Preference* - I have pictures of wolves on the walls of my home. I love their mysterious and independent natures.

56. *Personal Characteristics* - I love dogs and they take to me. I think humans and canines were ancient brothers or pack members in another time and place.

84. *Supernatural Communication* - I've had dreams or visions where large canine creatures wander in and out of my consciousness, yet this is never a frightening experience. I'm a member of a pack.

112. *Affinity Toward Animal* - I cannot understand why the U.S. Department of Interior encourages wolf eradication. There are no documented cases of humans being killed by wolves.

140. *Familial Bonding* - When I hear wolves howling (either live or on TV), the sound of it stirs my soul.

168. *Other's Perceptions* - People say I'm a free spirit and being around me is refreshing and invigorating.

196. *Environmental Preference* - I love the wild country, especially at night. I am not fearful and want to run and jump until I fall down in the tall grasses.

References

Bill, Willard. *Breaking the Sacred Circle.* State of Washington Superintendent of Public Instruction Office. Old Capital Building, FG-11, Olympia, WA 98504. 1988.

Brown, Vinson. *Native Americans of the Pacific Coast.* Naturegraph Publishers. Happy Camp, CA 96039. 1990.

Bruchac, Joseph. *The Native American Sweat Lodge – History and Legends.* The Crossing Press. Berkeley, CA 1993.

Cassidy, James J. Jr. *Through Indian Eyes – The Untold Story of Native American Peoples.* The Reader's Digest Association, Inc. Pleasantville, NY. 1997.

Cathryn Arwyn. *c/o Cathyn's Crystals.* The Maland Building, 1824 E. 12th Ave. Spokane, WA 99202. 2007.

Crow Dog, Mary. *Lakota Woman.* Harper Perennial. 10 E. 53rd St, New York, NY 10022. 1991.

Crystal Awareness Guide. Legion of Light. SAFC Press. Sunderland, SR5 1SU, England.

Curtis, Natalie. *The Indians' Book.* Bonanza Books. 225 Park Avenue South, New York, NY. 10003. 1987

George, Chief Dan. *My Heart Soars.* Hancock House Publishers. 3215 Island View Road, Saanichton, BC, Canada. 1974.

The Holy Bible – King James Version. Books, Inc. Publishers. New York, NY.

Indians of North America. Cartographic Division, National Geographic Society. Washington D.C. 1989.

Kroeber, Alfred L. *Handbook of the Indians of California.* Bureau of American Ethnology. Washington, D.C. 1925.

Lake, Medicine Grizzlybear ... *Native Healer – Initiation Into an Ancient Art.* Quest Books of the Theosophical Publishing House. P.O. Box 270. Wheaton, IL 60198. 1991.

Lake, Medicine Grizzlybear. *A Definition of Shamanism for Physicians, Psychologists, Teachers and Students.* American Indian Educational Assistance Center III. Gonzaga University. Spokane, WA. 1987.

Lake-Thom, Robert ... *Spirits of the Earth: A Guide to Native American Symbols, Stories and Ceremonies.* Penguin Books USA Inc. 375 Hudson St, New York, NY 10014. 1997.

Lake (Donohue), Tila Starhawk ... *Hawk Woman Dancing With the Moon: Sacred Medicine for Today's Women.* M. Evans & Co., Inc. 216 E. 49th Street Front. New York, NY 10017. 1997.

Leco, Mike. www.usatourist.com. 2007

Maze of Injustice: The Failure to Protect Indigenous Women from Sexual Violence in the USA. Darryl Fears and Kari Lydersen. Amnesty International. 2007.

Neihardt, John G. *Black Elk Speaks.* Washington Square Press Publications. 1230 Avenue fo the Americas, New York, NY 10020. 1972.

Pipestone Indian Shrine Association. P.O. Box 727, Pipestone, MN 56164. 2007.

Stein, Diane ... *Gemstones and Crystals.* Crossing Press. P.O. Box 7123, Berkeley, CA 94707. 1996.

Twin Cities Public Television. 172 E. Fourth Street. St. Paul, MN 55101.
(651) 222-1717. 2007.

WarCloud, Paul. *Dakota Sioux Indian Dictionary.* Tekakwitha Fine Arts Center. P.O. Box 208, Sisseton, SD 57262. 1989.

Webster's Collegiate Dictionary – Fifth Edition. G. & C. Merriam Co. Springfield, Mass. 1939.

Webster's Ninth New Collegiate Dictionary. Merriam-Webster, Inc. Springfield, Mass. 1991.

Westenberger, Theo. *Dancing in Honor of Their People.* Smithsonian Magazine. February 1993.

Referenced Internet Web Sites:
 www.aaanativearts.com
 www.usatourist.com
 www.sbgmusic.com
 www.nativehealer.net

Appendix
Lummi Nation Names for the Months of the Year

The Lummi Indian community is located on the Pacific coast of the state of Washington, a short distance south of the Canadian border.

January	Moon of Crackling Branches
February	Moon of Deep Snow
March	Moon of the Chinook Winds
April	Moon of Budding Trees
May	Moon of Flowers
June	Moon of the Salmon's Return
July	Moon of Ripe Berries
August	Moon of the Dry Grass
September	Moon of Harvest
October	Moon of Falling Leaves
November	Moon of Frost's Return
December	Moon of Winter

About the Author

Stan Hughes aka Ha-Gue-A-Dees-Sas, (Seneca for "Man Seeking His People), is a retired public school administrator with an extensive publication background including an Editor's Choice Award from the International Library of Poetry. He worked many years as a consultant for the Indian Education Center doing parent education workshops and lecturing from coast to coast on the topics involved with teaching Native children. While serving on the board of the Urban Indian Center in Spokane, Washington, he was active in Indian Education issues in both Washington State and Oregon.

Although not enrolled in a federally recognized tribe, both of his grandmothers were of Native American descent and his deceased father considered himself an Ah-oh-ZE (half-breed) of the Blackfoot Nation of north central Montana. Hughes was born on Yakama Indian territory in Washington State and grew up in the Black Hills of South Dakota, considered sacred by the Sioux Nation. He is a Vietnam Era veteran serving in the U.S. Army from 1959 to 1965.

Hughes was trained by traditional Shamans from northern California and participated in the Rite of Passage to warrior status during a seven day fast and vision quest in the Big Horn Mountains of Wyoming.

Illustrations That May be Ordered

Native American Topic Illustrations From *Medicine Seeker* available in 8-1/2 x 11" prints. Signed and reproduced in black and white on top quality velum art paper suitable for framing—mailed flat.

Each print: $8.00

In the space following name of the illustration, indicate the number of copies you wish to order.

Your Name: _____

Address:_____

City/State/Zip:_____

Phone No: _____

(Pg vii)	Antelope___	(pg.101)	Bald Eagle___
(pg.35)	Barn Owl___	(pg.117)	Bear Family___
(Pg. ii)	Bobcat___	(Pg. 34)	Bumblebee on Flower___
(Pg. 81)	Buffalo___	(Pg.154)	Cat Fish___
(Pg. 55)	Ceremonial Pipe___	(Pg iv)	Coyote___
(Pg. 47)	Cougar___	(Pg. 75)	Gate to Wounded Knee___
(Pg. 150)	Deer___	(Pg 119)	Frog___
(Pg. 63)	Mountain Goat___	(Pg. 5)	Native Dancer ___
(Pg. 35)	Owl	(Pg. 17)	Osprey)
(Pg. 135)	Red Fox ___	(Pg. 89)	Petroglyph___
(Pg. 1)	Red Hawk___	(Pg. 124)	Squirrel___
(Pg. 23)	Winter Wolf___		

Send payment (cash, check, or money order) PLUS 10% for shipping and handling to

RAVENSWOOD
11322 E. 23rd Avenue
Spokane Valley, WA 99206
ATTN: Art Director

Total Amount Enclosed:_____

Available from NorlightsPress and
fine booksellers everywhere

Toll free: 888-558-4354 **Online:** www.norlightspress.com

Shipping Info: Add $2.95 for first item and $1.00 for each additional item

Name_____

Address_____

Daytime Phone_____

E-mail_____

No. Copies	Title	Price (each)	Total Cost
		Subtotal	
		Shipping	
		Total	

Payment by (circle one):

 Check Visa Mastercard Discover Am Express

Card number_____3 digit code_____

Exp.date_____ Signature_____

Mailing Address:
762 State Road 458
Bedford, IN 47421

Sign up to receive our catalogue at
www.norlightspress.com